the annual of the type directors club

TYPOGRAPHY

1 1

Watson-Guptill Publications
New York

Copyright © 1990 Type Directors Club

First published in 1990
by Watson-Guptill Publications,
a division of BPI Communications, Inc.,
1515 Broadway, New York, N.Y. 10036

The Library of Congress has cataloged this
serial title as follows:
Typography (Type Directors Club [U.S.])
Typography: the annual of the Type Directors Club. —1—
New York: Watson-Guptill Publications, 1980-
v.: ill.; 29 cm.

Annual.
ISSN 0275-6870 = Typography (New York, N.Y.)

1. Printing, Practical—Periodicals. 2. Graphic arts—
periodicals. 1. Type Directors Club (U.S.)
Z243.A2T9a 686.2'24 81–640363
AACR 2 MARC–S
Library of Congress [8605]

Distributed outside the U.S.A. and Canada by RotoVision, S.A.,
Route Suisse 9, CH–1295 Mies, Switzerland

Manufactured in Japan
1 2 3 4 5 6 7 8 9 / 95 94 93 92 91 90

Senior Editor: Marian Appellof
Associate Editor: Carl Rosen
Designer: Larry Yang
Page Makeup: Jay Anning
Photographer: Michael Newler
Production Manager: Hector Campbell
Compositor: TGA Communications, Inc.
Set in Univers 67 and Century Old Style.
ISBN 8230–5545–0

CONTENTS

4

Kathie Brown is a principal of U.S. Lithograph, typographers, and U.S. Lynx Inc., a computer systems company. She is secretary-treasurer of the Type Directors Club and a member of the editorial collective for the feminist publication, Heresies. She is also an artist who regularly exhibits in alternative spaces and has curated numerous exhibitions.

Today there are more people, both professionals and amateurs, practicing typography than ever before and thus more need for standards of excellence to guide the untutored. At the Type Directors Club we hope our annual competitions do just that. We highlight the most beautiful, audacious, cunning, intoxicating, and serene typography of the year in order to honor our colleagues and inspire everyone's practice of this subtle art.

Our Charge to the Jury
The mere presence of words in a piece is not typography. Somewhere in the collaboration of typeface, sizing, and placement and in the interrelationship of a word with other words, images, and type masses lies typography.

Our competition highlights the central and creative place of typography in the design process. Words make images and shapes but also convey meaning in a direct rather than associative way. The interplay of the concrete and the abstract, the precise and the allusive, the logical and the dreamlike, the banal and the fantastic—this is what makes visible language so fascinating.

What the Jury Chose in Response
TDC 36 is a judicious mix of the frankly experimental and the best of mainstream design. The show is less calligraphic than last year's selection, more from the mouse than from the hand. This year's winners make up, then, a show with less sensuousness and prettiness and more of typographic architecture.

KATHIE BROWN

The winners, reflecting the entries as a whole, demonstrate that designers are lavishing attention on the details of text settings or, as judge Erik Spiekermann calls it, *micro-typography*. Even what would, in the past, have been treated as display type is set in small sizes, receiving emphasis from its position rather than from its size or decorativeness. (A lot of face mixing in consequence!)

The viewer will see the growing influence of *Emigre* and of Zusanna Licko's Macintosh fonts. Works for the wall and the page are being copied from works on the computer screen; designers are creating textural patterns from a complex weaving of manipulated images, text-sized type, and "big-bit" icons.

A few other trends might be mentioned: the literary and romantic spirit of revivalism; curved, circular, and contorted type; some things that are just pretty; the deconstructed surreal and the old-fashionedly surreal; corporate design controlled at too perfect pitch; funk and a little punk; and text, text, text.

Judge's Choice Awards
This year each judge chose a special piece to receive a Judge's Choice Award. These individual awards are not "best-of-show" but represent personal choices of the judges; they offer each judge a chance to speak in his or her own voice rather than in the anonymous voice of the jury. I hope the comments on these pieces engender some debate and insight into each judge's individual esthetic.

Best of all, from the chairperson's vantage point, I think the judges enjoyed themselves. At least they spent lunchtime still talking about type and what the irreducible aspects of alphabets are and how to draw them.

CHERYL A. BRZEZINSKI is the creative director of the Minor Design Group Inc., Houston, Texas, which she joined in 1987. She is also a full-time educator and has been an assistant professor of graphic design at the University of Houston since 1986. Brzezinski has also taught at Western Michigan University, in 1985-86, and at the University of Hawaii, from 1982 to 1985.

Brzezinski has received awards for her work from many prestigious organizations, including the American Institute of Graphic Arts, the Society of Typographic Arts 100 show for the American Center for Design in Chicago, the University and College Design Association, the Type Directors Club New York, *Print* magazine, and the American Museum Association. Her work has been included in the show "Design Excellence: Fifty Posters of the Decade" and in the book *Type and Image*, by Philip B. Meggs. She has been honored by inclusion in the Posters of Popular and Applied Art Permanent Collection of the Library of Congress in Washington, D.C.

TIM GIRVIN, principal of Tim Girvin Design, Inc., Seattle, Washington, is a graphic designer, lettering artist, and illustrator whose work is known internationally. Girvin's philosophy is one of craftsmanship, attention to detail, and a constant effort to develop special approaches for each of a wide variety of clientele. His design group seeks to express a new vitality and sense of elegance and beauty in the designs produced and to continually project originality in each solution undertaken.

Girvin graduated from the Evergreen State College and has traveled extensively abroad to study book and type design, calligraphy, and illustration. After a summer study at the Imperial College in London, Tim met with renowned calligraphers and type designers in a series of dialogues that took him to France, Germany, Austria, Switzerland, and finally as a guest speaker on type design at a conference in the U.S.S.R. Girvin resides with his wife, Kathleen, and two daughters in Queen Anne, a short commute from his downtown Seattle office.

KIT HINRICHS was born and raised in Los Angeles and studied at the Art Center College of Design. After graduating in 1963, he worked as a designer in several New York design offices before forming the design partnership of Russell & Hinrichs. In 1972 he joined with his wife, Linda, to form Hinrichs Design Associates. In 1976, they joined forces with Marty Pedersen, Vance Jonson, and Neil Shakery to form Jonson, Pedersen, Hinrichs & Shakery. Hinrichs remained a principal there until he, Linda, and Neil merged with Pentagram Design in 1986.

Hinrichs has been an instructor at the School of Visual Arts in New York, at the Academy of

Art in San Francisco, and at the California College of Arts and Crafts in San Francisco. He has been a guest lecturer at the Stanford Design Conference and numerous other design associations and universities across the country.

Hinrichs has received several gold and silver awards from the New York and the Los Angeles Art Directors Clubs, in addition to honors from the Society of Publications Designers, the Type Directors Club, the American Institute of Graphic Arts, the San Francisco Art Directors Club, and *Financial World Magazine*. Hinrichs most recently received the Margret Larsen Award for excellence in art direction from the San Francisco Show.

His work has been published in several national and international publications, including *Communications Arts, Graphis,* and *Idea Magazine*. His work is also part of a permanent collection at the Museum of Modern Art. Hinrichs has co-authored two books, *Vegetables* (Chronicle Books, 1986) and *Stars & Stripes* (AIGA, 1987).

JANE E. KOSSTRIN received her B.F.A. in design from Carnegie-Mellon University and a M.F.A. in design from Cranbrook Academy of Art.

Upon locating in New York, Kosstrin worked on projects for such firms as Revlon, American Express, and Con Edison.

In 1979, Kosstrin and David Sterling, former art director for *ID* magazine,

founded Doublespace, a graphic design and advertising firm based in New York City, which developed as its initial venture the publication and design of *Fetish: The Magazine of the Material World*, a quarterly tabloid that brought Kosstrin and Sterling some of their first clients, including the American Museum of the Moving Image, the Brooklyn Academy of Music, and Barneys New York.

Kosstrin's and Sterling's firm has since evolved from being a recognized leader in experimental graphics to being an innovator and strong competitor in the American marketplace.

DANIEL PELAVIN

a designer and illustrator, works for clients in advertising, publishing, and graphic design. His work is best recognized by its precisely drafted shapes, a unique palette, and the use of vintage typography.

His illustrations and book covers have earned recognition from the American Institute of Graphic Arts, the Society of Illustrators, *Graphis Posters, Print's Regional Design Annual*, Mead Paper Company, *Communications Arts, Print Casebooks*, the Society of Publication Designers, the Type Directors Club, and the Art Directors Clubs of New York, Boston, San Francisco, and Washington, D.C.

Pelavin is included in *Outstanding American Illustrators Today*, vol. 2, and featured in articles in *Print, Art Product News, Idea* (Japan), *U&lc, How,* and *Grafica* (Brazil). His work is included in two recent books: *Designing with Illustration*, by Steven Heller, which was published by Van Nostrand Reinhold in 1990, and *Type and Color*, by Alton Cook.

7

ERIK SPIEKERMANN is a typographic designer and author of books and articles on all aspects of visual communications. He studied the history of art at Berlin's Free University, financing his studies by running a typesetting and printing business from a basement.

8

Spiekermann spent a few years living and working in London and now heads

MetaDesign, a design studio in Berlin that specializes in information design, including forms, public transport signage systems, as well as housestyles and newspaper design. A lot of their clients start with an *A* and are known to most designers, for example, Adobe, Agfa Compugraphics, Aldus, Apple, and others.

He has designed several text typefaces for phototypesetting and digital systems, some of them as exclusive faces for corporate design programs. His latest typeface, ITC Officina, is to be released by September 1990. His book *Rhyme and Reason: A Typographic Novel,* originally written for phototypesetting, has become something of a standard for the world of desktop publishing, too. He has just published a second book, written for students, again all about type and typography.

Spiekermann lectures at universities and colleges in Europe and the United States. He is a member of the Typeface Advisory Board of ITC in New York, member of the Board of Directors of the ATypI, Fellow of the Society of Typographic Designers in the United Kingdom, member of the Type Directors Club, and member of the Bund Deutscher Grafik-Designer, among other groups.

JIM WAGEMAN is director of art and design at Stewart, Tabori & Chang in New York. Most of his professional career has been spent in and around book publishing, coming up through the ranks at university presses, moving on to the Museum of Modern Art in New York, then into trade publishing in the area of illustrated books, both on staff and

as an independent designer and consultant. His work has received recognition from the American Institute of Graphic Arts, the Type Directors Club, the Association of American University Presses, the Art Directors Club of New York, and other competitions, including a Gold Medal at the International Book Design Show in Leipzig, East Germany.

CHOICE

A particularly complex type solution inspired one juror to comment, "it looks as if designers are being given too much time to design." Although each juror selected work deemed "excellent" by his or her own criteria, my aim was typography that leads us in new directions. The work should be challenging enough to inspire dialogue and make us think. Our type appetites seem voracious at the moment. The liberating effect of the computer on the design process has prompted other avenues of exploration: mixing numerous fonts on the page, new font designs, type manipulations, hand-drawn letterforms, and the use of historical typefaces that have long been ignored. These have been investigated before, but there is a renewed enthusiasm. In a real break from the modernist approach, any and all of the above may be mixed together in one composition. These stylistic ventures are given a twist by the additional preoccupation with linguistics. There are several densely layered deconstructivist pieces that epitomize the type-as-image investigation (including Allen Hori's "Typography as Discourse"). These pieces have had an exciting presence in their ability to promote dialogue and critical evaluation between designers. Typography is enjoying a resurgence and a break from modernist restrictions. These interests have created design that is exciting and even controversial.

I have chosen an elegant and understated self-promotion piece for the design firm Concrete as my favorite. It incorporates language in a way that encourages the reader to participate in that fascination. The first time the copy appears it is a list of nouns. These are further defined on the next page by single word descriptions: simplicity (works), limits (stimulate), strengths (produce), skill (disciplines), flexibility (responds), creativity (reaches), inventiveness (reframes), elegance (defines), passion (balances), communications (resonates). On the final page, these terms are incorporated into descriptive paragraphs that more fully define the attributes and objectives of the design firm. The poetic arrangement of this information is juxtaposed with Dada-inspired photographs and tactile papers. The information expands as the reader progresses through the piece. It is a fine union between concept, copy, beauty, and risk.

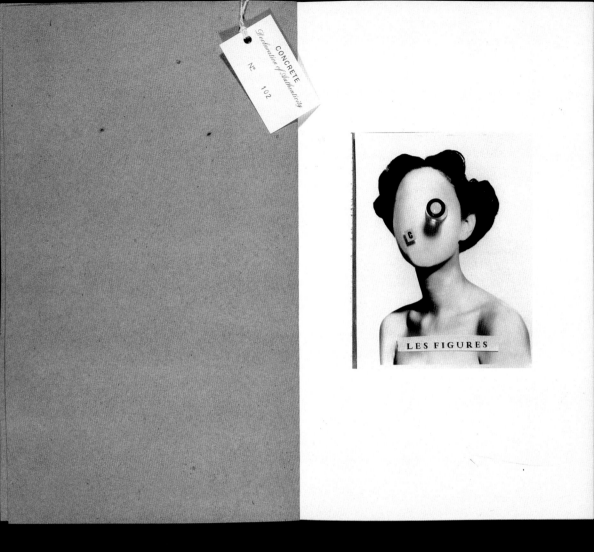

LES FIGURES

Brochure
Typography/Design Jilly Simons and David Robson,
Chicago, Illinois
Typographic supplier Master Typographers
Studio Concrete
Client Concrete
Principal type Amsterdamer Garamont
Dimensions 8 x 12 in. (20.3 x 30.5 cm)

We were charged with the mission of finding typographic greatness. What we did find was a tremendous amount of competent work and some examples of excellent typographical design. It was clear, however, that the current state of affairs in design, particularly as it relates to typographic application, was one of experiment and transition.

12

A large group of material played upon desktop-related manipulation of typographic formats and treatment as well as stylistic directions that had a particular period or imitative design stance in mind. I tried to shy away from awarding repetition, but concentrated instead on awarding entries that displayed freshness and innovation. Many pieces exhibited interesting juxtapositions of typography and illustration or photography, but the goal was to concentrate solely on the expression of language and meaning in typography and to establish strength in those conceptual connections.

My favorite piece? I felt that the "Dimensions" program for Simpson Paper designed by Cross Associates was a particularly skillful combination of typographic vision, literary content, and illustration. The format of the piece, the simplicity of its design, the craft of the typographic treatments, and the conceptual understanding of language wove that publication into a solid and innovative piece of visual communication.

Michelangelo had little interest in the forms of nature, believing that Man was the noblest subject, next to God. He spoke scornfully of landscape painters, but in 1556, when he was already over 80, he visited Spoleto. "discovered" external nature, and wrote to a friend: "With considerable difficulty and expense I have had during these days a great enjoyment of the mountains of Spoleto ... truly, one cannot find peace except in the woods." He then tried to write a pastoral poem, but its scenic background vanished after two stanzas, with humans possessing the last thirteen stanzas of the poem without the intervention of a single blade of grass.

"... seems to me the true artist must go from time to time to the elementary forms — sky, sea, mountain, plain, and these things pertaining thereto, to sort of nature himself up ..."

John Marin

"My concern is with the rhythms of nature ... the way the ocean moves ... The ocean is what the expanse of the west is for me ... I work from the inside out, like nature."

Jackson Pollock

"Yes madam, Nature is creeping up."

James McNeill Whistler
(in answer to a woman who said that a landscape resembled his paintings.)

"I wish all people were trees and I think I could enjoy them."

Georgia O'Keeffe

"... painting brings philosophy and subtle speculation to the consideration of the nature of all forms — seas and plains, trees, animals, plants, and flowers — which are surrounded by shade and light. And this is true knowledge and the legitimate issue of nature; for painting is born of nature ..."

Leonardo
Notebooks

We have obviously become a profession whose technical and styling capabilities have reached a very high level. The choice of handmade papers, 1950s photographic styling, elegant varnishes and, of course, the most *au courant* type styling were all in abundant evidence. My concern always is that in our rush to be the most progressive, take the most chances, and, as judges, to reward the most innovative work that we not lose sight of our responsibility to the audience for whom we are designing.

A refreshing example of work that falls into that category is a "History of Baseball" for Consolidated Paper, designed by Azchen & Jacobi in Minneapolis. Of all the pieces in the show, it may best represent a contemporary design while never losing touch with the subject matter or its audience. Each spread brilliantly describes a different period in baseball history with style and content. It reveals a spirit of the times yet never feels old fashioned. Typographic pacing of the book brings a surprise to every page yet never loses its overall sense of the subject. My only regret is that I didn't do it!.

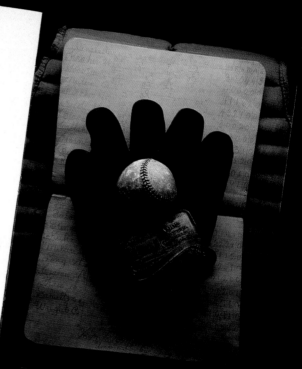

Book
Typography/Design Leslee Avchen and Laurie Jacobi,
Minneapolis, Minnesota
Typographic supplier Alphagraphics One
Agency Wardrop-Murtaugh-Temple
Studio Avchen & Jacobi, Incorporated
Client Consolidated Papers
Principal types Various
Dimensions 9 x 12 in. (22.9 x 30.5 cm)

When asked to participate on the jury for the Type Directors Club, I accepted the position of visceral judge. Being well known for my own work, which at its best is charged with emotionality, this seemed like a natural. At the start of the show we were asked to choose a piece or two that we felt best exemplified our idea of typographic excellence. This was a difficult assignment, since another directive was to judge this piece first for its typography and then consider the other elements that make the piece successful.

The show featured a lot of imitation. There were times when one was not sure what had come first and why the typography had been chosen for that particular solution. For me, type choice and presentation must reflect an idea and assist the viewer with the communication. My two choices for personal favorites represent two divergent voices that operate within my own psyche. The soft, feminine voice was attracted to a classic packaging solution, and the other voice to a raw, emotional invitation where the type and image combined to speak directly to the viewer. I was attracted to these two entries for their typography, color, texture, and composition choices.

The packaging for Lavadin Les Huiles Essentielles appealed to me for how its coloration, and the use of curvaceous script, in combination with letterspaced sans-serif typography helped communicate the feeling of the product. As a woman, I was attracted to this package that seemed to stand out in a sea of sameness. The choices made by the designer helped coordinate the bottle and packaging to give the user a complete experience. I could easily imagine the process of opening the warm lavender-and-green package to reveal a beautiful lavender-tinted bottle. The elegant handling of the typography made it a fine addition to any woman's vanity.

The invitation produced for the Art Center Downtown gallery (p. 182) appealed to the raw, more emotional inner voice. The piece was probably one of the most inexpensively produced pieces in the show and one of the most effective. It was an invitation for an exhibition of a series of photographs of homeless men. The text, which was written in typewriter type along with a repetition of black-and-white photographs—tinted with warm orange gradations of light—spoke directly to me. As I began to analyze the piece it became clear that a powerful choice of image, a provocative use of text, and the edgy handling of the typography helped communicate the message. Its placement and rawness made the caption, "If I only had my own place, I wouldn't have to wait in line," juxtaposed with a photograph of a homeless man waiting in line to use the lavatory, incredibly powerful.

Communication need not be expensive. Communication need not be stylish. Communication just needs to work. Two divergent solutions chosen—each with its own personality, each a gem for its audience—for their own power to communicate.

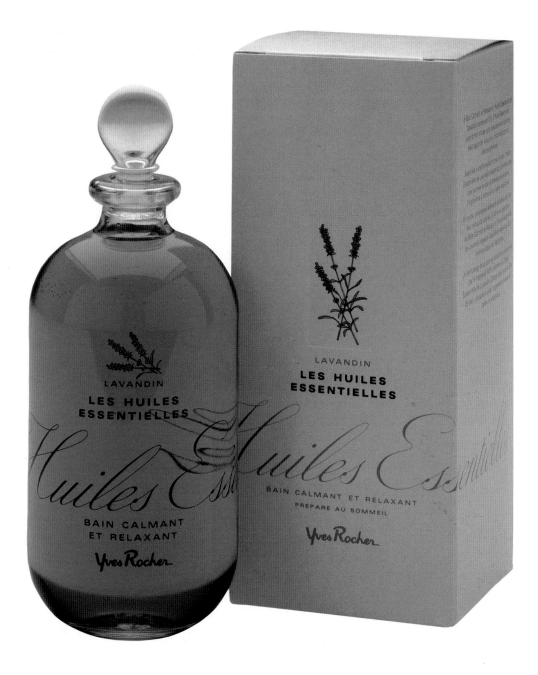

Packaging
Typography/Design **Lucilla Scrimgeour,** *London, England*
Letterer **Mike Pratley**
Typographic supplier **Conways**
Agency **Lewis Moberly**
Client **Yves Rocher**
Principal type **Univers**

A typographic work that needs explanation is not a great work, for the purpose of typography, more than simply to communicate, is to express, illuminate, and even enlighten. A design that needs to be defended in indefensible. Though experimentation in typography is certainly important, don't force me to try and comprehend an experiment that has failed.

With this in mind, I searched through the many entries to find work that spoke for itself, not just clearly, but with eloquence. I found numerous pieces with correct typography and even a few with splendid typography, but in the work I choose to speak of here, type, image, composition, and color are integrated to create a design that needs no interpretation to be understood and appreciated.

The Gorky Russian Beer packaging is engaging in the simplicity of a graphic approach to a problem that is too often solved with fake seals or images out of a handbook on heraldry. Although a strong stylistic approach can sometimes overpower, this packaging is on the mark for a beer from the U.S.S.R.

Sans-serif type in a variety of weights both roman and italic, unusual for this type of product, nevertheless complements the "industrial revolution" imagery. The use of numerals to denote the different varieties—Stout, Light, and Ale—enhances the importance and function of the typography.

The matte black finish of the bottle contrasted against the glossy black, red, cream, and metallic gold of the label creates a package almost too nice to make it past even the most enlightened focus group, though there's more than enough room for packaging of this caliber on the shelves of my "ideal" supermarket. To summarize my feelings about this judge's choice, I would say, "Gee, I wish I had done that."

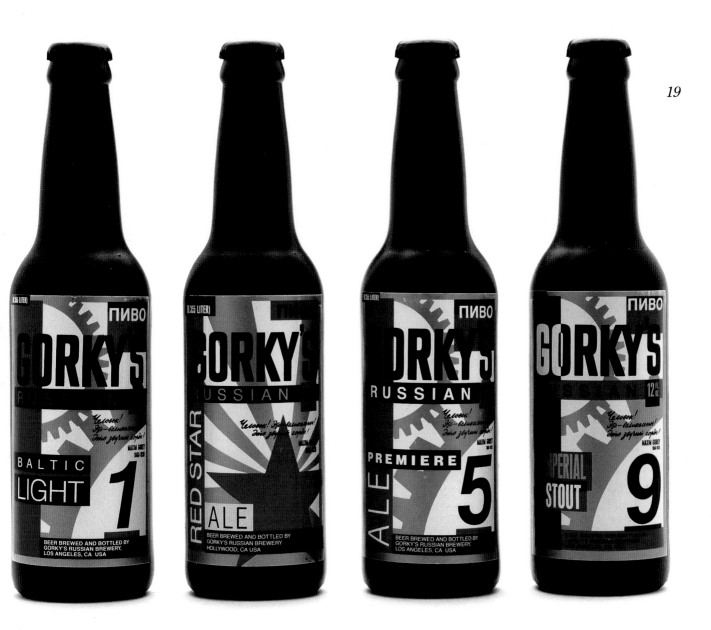

Packaging
Typography/Design **Henry Vizcarra and William Heustis,**
Los Angeles, California
Typographic supplier **Scarlet Letters**
Studio **30/60 Advertising & Design**
Client **Gorky's**
Principal type **Helvetica**

Judging this year's competition was fun because of the other judges; it was hard work because of the lack of attention to typographic detail; and it was trying because of obvious trends that half of the people followed as if there were laws.

I shall not even try to talk about the intellectual level of typographic design, about the dominance of form over content—let's just say that the old motto still stands for a lot of people: "It's not enough to have no ideas, you also have to be unable to express them."

All this can be stated quite candidly, as it doesn't apply to the work we've picked for this book. If, however, I had my way and interpreted "typographic excellence" to include proper handling of things like wordspaces, letterspacing (a.k.a. tracking), line-breaks, leading, or even choice of typeface, the book wouldn't be half as thick.

Let me briefly describe why I picked a brochure about Vitra chairs—not necessarily as my favorite, but as the one I wanted to write about: Okay, so it is all about European chairs designed by European designers for a European manufacturer. And the brochure is designed by an American who spent a number of years studying at a European college not very far from that factory near the border between Switzerland and Germany.

What I actually like about the piece is the designer's modesty. The brochure features chairs, that is, photographs of chairs. There are lots of photographs: different shapes, colors, and textures; different backgrounds, sizes, and details. But just as the pictures approach a level of overkill, there are some columns of type to re-instate sanity, order—the element of information after all that emotion. Not that the typography lacks an emotional quality; while it manages to convey a fair amount of information in three languages, it also manages to entertain the reader. It doesn't sing or dance, merely to show off the designer's amazing abilities, but it highlights, points out, and surprises. All this without resorting to silly gimmicks like setting whole pages in Copperplate all caps, mixing Cochin Italic with Eurostile Light Extended, wavy lines of text containing at least ninety characters, to name but a few.

I could query the wisdom of taking Futura Book at 8 point and reversing it out of four very light colors—and I do!—and I wouldn't run that same face in black over dark gray backgrounds. But that is nit-picking. All the typographic details are there: proper tracking, wordspacing, line-feed, and thoughtful hyphenation in all three languages.

Enough praise. I like the piece and I wish there had been many more such thoughtful, cheerful, and thoroughly professional entries that serve the client's intentions as well as the definition of typographic excellence.

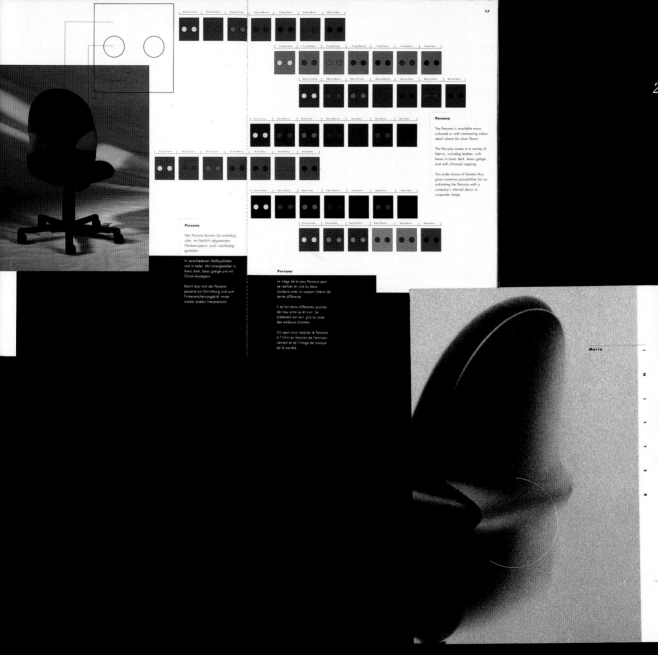

Brochure
Typography/Design April Greiman, *Los Angeles, California*
Typographic supplier In-house
Studio April Greiman Inc.
Client Vitra International
Principal type Futura
Dimensions 11¾ x 8¼ in. (29.9 x 21 cm)

One of the more intriguing pieces in the show, for me, is the University of Nebraska Press's *Telephone Book: Technology—Schizophrenia—Electric Speech*, clearly the product of a collaborative effort on the parts of designer Richard Eckersley, compositor Michael Jensen, and author Avital Ronell. What are we to make of this outrageous piece of book typography that gleefully sets about breaking most traditional rules and conventions at one point or another within its pages, flouting all concepts of legibility, consistency, and clarity of structure? The offenses run rampant: letterspaced lines—whole paragraphs of them; rivers of white running through entire pages—obviously the work of a deliberate perpetrator; paragraphs so tightly leaded that the lines overlap; justified columns set on such a ridiculously narrow measure that one could drive a truck through the resulting word spaces; boldface words within the text that explode off the page with greater force than some of the chapter heads (which, themselves, refuse to conform to any single style). We won't even mention those places where near-total-to-total illegibility has been achieved by throwing the type out of focus, printing it flopped, double printing the same copy out of register, or changing point sizes within individual words and reducing letterspacing so severely that the letters pile up on top of one another. Beatrice Warde, advocate of a typography that is as transparent as a "crystal goblet," must be turning over in her grave!

The designer's inspirations for this little book would seem to have derived not from the likes of Beatrice Warde, however, but from sources as various as Laurence Sterne's *Tristram Shandy* and Marinetti's proposals for a Futurist typography. And what an impressive achievement, on its own terms, this piece of deconstructed typography is, how appropriate to the deconstructivist text it serves, which—to borrow from the flap copy—"installs a switchboard that hooks up diverse types of knowledge [philosophy, history, literature, and psychoanalysis] while rerouting and jamming the codes of the disciplines in daring ways." In fact, having seen the text presented in this way, it's difficult to imagine how a conventional handling of it could have been successful. This is not to argue that—God forbid—this should become the latest faddish formula to follow, allowing the designer ostentatious self-expression at the expense of textual coherence. But for this author, who rejects a limpid style, announcing instead that "we shall constantly be interrupted by the static of internal explosions and syncopation—the historical beep tones disruptively crackling on a line of thought," how better to be served than by the beautiful cacaphony that is created here. It's a tour de force. Brrrrr rrrrrrrrrrr rrrrr aaaaaaaaaaaaaaaaaaaa aaaaa aaaaa aaaaaa vooooooooooO!

Book
Typography/Design **Richard Eckersley,** *Lincoln, Nebraska*
Typographic supplier **University of Nebraska Press**
Studio **University of Nebraska Press Production Department**
Client **University of Nebraska Press**
Principal types **Galliard and Helvetica Light**
Dimensions **5½ x 10 in. (14 x 25.4 cm)**

The Type Directors Club of New York first issued this challenge thirty-six years ago: send us your most typographically inspired pieces to be judged against today's best typography. We're looking for typography wherever it is, in magazines and books, on boxes of breakfast cereal, in the titles on the morning news, on the facades of buildings, even on the heels of our shoes.

Today there are both more dabblers in and serious practitioners of typography than ever before. And more need for standards of excellence to guide the untutored. By choosing the most beautiful, audacious, cunning, intoxicating, and serene typography from all areas of design the Type Directors Club 36th annual competition hopes to be that guide.

We are looking for typography that stands on its own feet. As in the movies, production values can mask structural weaknesses or they can light up an already beautiful face. The design we want to honor could have been published in black and white; it used color and texture to give radiance to a beautiful typographic structure. And we don't want typography as mere caption to an overwhelming image. The type should be its own strong image.

The Type Directors Club of New York announces an open call for entries in an international competition to measure excellence in contemporary typography, whether the letterforms are executed in typesetting, calligraphy, or handlettering. Or cut from stone or metal or molded in plastic. The winners of this competition will be exhibited internationally and published in *Typography 11*, the all-color annual of the competition.

The Type Directors Club, founded in 1947, is a professional organization of typographic and graphic designers, calligraphers, handletterers, and users of type. Its membership is worldwide.

All entries must have been published or produced in 1989. Entries can have been executed in virtually any medium and can be either single pieces or a design series. Anyone associated with the work as producer or sponsor may submit the work. Specific entry requirements are detailed on the other side of this poster.

Although awards are not given in categories, the judges will be shown the entries in company with similar pieces to minimize the influence of physical factors. Judges' special awards will also be made on an open basis.

A portion of your entry fees will be used for the TDC Scholarship Fund.
Kathie Brown, Chairperson, TDC 36
Carol Wahler, Executive Director, TDC

call for entries

Entries chosen by the jury will receive Certificates of Typographic Excellence. They will be exhibited in New York City at the TDC Center and appear in *Typography 11*, the annual of the 36th TDC Exhibition to be published by Watson-Guptill. Winners should be prepared to supply five additional copies of winning entries for use in exhibitions that travel through-out North America, South America, and Europe and in Australia, New Zealand and eastern Asia. Individuals and firms that contributed to producing the winning entries will be credited in the exhibition and in *Typography 11*.

This year the judges will also choose individual judges' choice awards to expose their special interest in a particular piece of work.

jury
Cheryl Brzezinski,
graphic designer/educator,
Minor Design Group,
Houston
Tim Girvin,
graphic and type designer,
Tim Girvin Design, Seattle
Kit Hinrichs,
partner,
Pentagram, San Francisco
Jane Kosstrin,
art director and designer,
Doublespace, New York
Daniel Pelavin,
designer, letterer, and
illustrator, New York
Erik Spiekermann,
graphic and type designer,
Meta Design, Berlin
James Wageman,
art director,
Abbeville Press, New York

3 vi 6

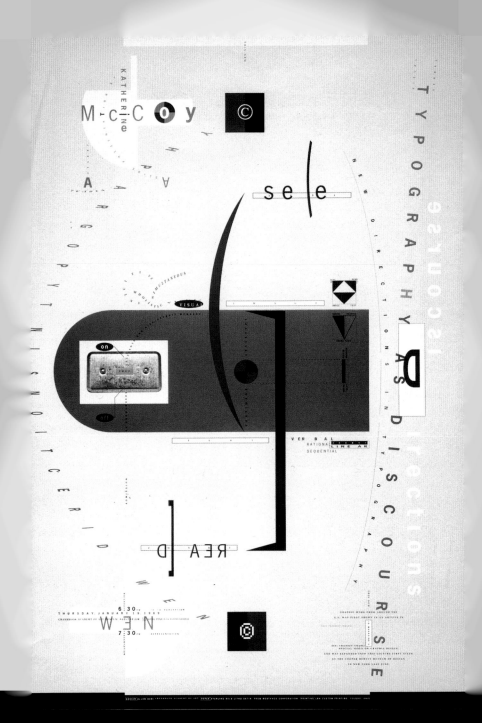

Poster

Typography/Design **Allen Hori,** *Bloomfield Hills, Michigan*
Typographic supplier **In-house**
Studio **Cranbrook Academy of Art Design Department**
Client **Katherine McCoy**
Principal type **Adobe News Gothic**

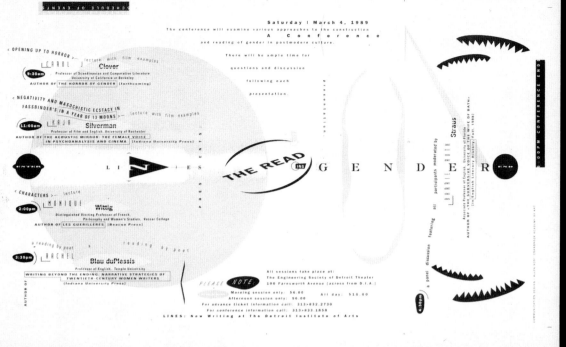

Typography/Design Allen Hori, *Bloomfield Hills, Michigan*
Typographic supplier In-house
Studio Cranbrook Academy of Art Design Department
Client The Detroit Institute of Arts
Principal types Univers and ITC Franklin Gothic
Dimensions 17 x 11 in. (43.2 x 27.9 cm)

Iopa Veles

Iopa.
Named after
the biblical Job
in Hawaiian.
Twenty-four years old,
three-quarters Hawaiian,

one-quarter Chinese. yah?" Works the hard to beat,
Powerfully built, chiseled embryonic skimboard
face reminiscent of the circuit (for Native
Duke. Born on Oahu's West
Shore, lives there still:
 Action). Competes in
"...lovin' every minute of

it." Is one scalding-hot skim-
 California and Hawaii.
boarder. Featured each day
 Favorite spots: Yokahamas
on the opening of Channel 7
and Sandy Beach. Been skimboard-
 News. Famous for getting
ing for nine years, competitively for
 outrageous air. "Before I
five. "I been doin' skimboard from
 approach the wave I
when we were small kids. One day

they had this contest goin' on, so we grab the board and just
tried it and we started winning. But fly—do couple loops in the
I'm only in it for the fun." Also surfs, air. You see picture, you go
dives, hunts and shoots hoops. The crazy, I think." Low-key
Hawaiian Sportsman. Top three:

Food, skimming and women style: "We're not the
("food first, you can get women best but we're kinda

anytime"). Not too fond
of guidos (guys all dressed
up and nowhere

to go) and baldheaded
men. Future plans:
Get married (off and on).
Memorable quote:

"Another bummah day
 in para-dise, eh?"

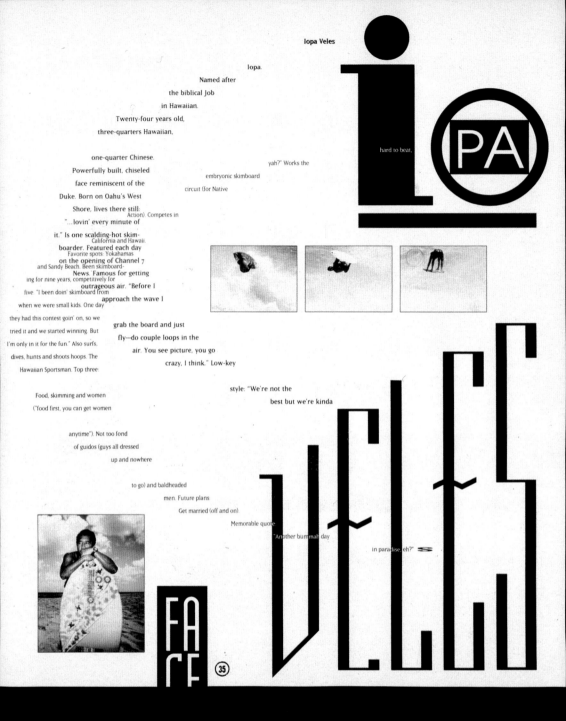

Editorial
Typography/Design David Carson, *Del Mar, California*
Typographic supplier In-house
Studio Carson Design
Client Beach Culture Magazine
Principal types Matrix and custom designs
Dimensions 10 x 12 in. (25.4 x 30.5 cm)

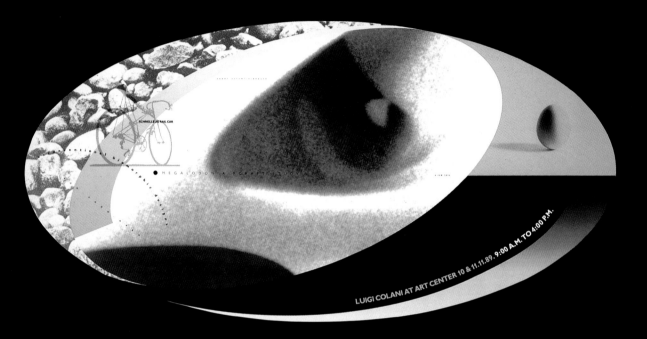

LUIGI COLANI AT ART CENTER 10 & 11.11.89. 9:00 A.M. TO 4:00 P.M.

Poster
Typography/Design Rebeca Mendez, *Los Angeles, California*
Letterer Rebeca Mendez
Typographic supplier CCI Typographers
Studio Art Center College of Design, Design Office
Client Art Center College of Design
Principal types Gill Sans and handlettering
Dimensions 30 x 15 in. (76.2 x 38.1 cm)

TIME

THE
ONLY DIFFERENCE
BETWEEN
THE DIFFICULT
AND
THE IMPOSSIBLE
IS THAT
THE IMPOSSIBLE
TAKES MORE
TIME

❖

SELECTED

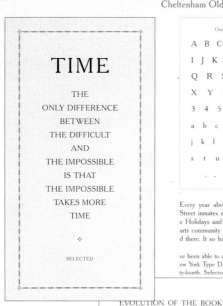

Characters in Complete Font

A B C D E F G H
I J K L M N O P
Q R S T U V W
X Y Z & $ 1 2
3 4 5 6 7 8 9 0

a b c d e f g h i
j k l m n o p q r
s t u v w x y z
. . - ' : ; ! ?

New York's Annual Exhibition Thirty-fourth

Wherever type is used to convey a message, there you will find the Cheltenham in favor. Get busy

SOLD IN WEIGHT FONTS AT OUR BODY TYPE PRICES AND DISCOUNTS

¶ All of our faces of Display type are now sold in Weight Fonts at our regular Body type prices and discounts.

BUY YOUR JOB TYPE IN WEIGHT FONTS

EVERY full grid of Job type means an increased profit for you on account of time saved in composition. Experience proves this. Buy the most used sizes of Job type in usable Weight Fonts and add balance of series in regular Job fonts. It will save you money

Every year about this time we Wellington Street inmates dust ourselves down from the Holidays and try to entertain the graphic arts community with the odd event here and there. It so happens that this year we have been able to again get our hands on the New York Type Directors Club Show – the thirty-fourth. Selected by a jury of eminent typographic practitioners, this is the umpteenth time C&B has sponsored the visit to our fair city of Toronto. Our friends at the Berthold Type Centre have once again offered us their facilities to display the exhibit, and we also want to mention that Compugraphic are the overall sponsors of the travelling show. Which means that they set up the moolah to get the thing mounted, and offer administrative facilities to get the show travelling around in an organized a manner as possible. They have also implemented the display system that we are using this year, which is apparently rather clever. One will realize, of course, that the promotional copy is being written to close the show is actually here. The panel system is designed to jump right out of the packaging case and assemble itself in no time at all. See it could be the year for love is taken forgrando on the part of the organizers, which would be rather refreshing. This pirate concept, copy and design came from Ed Cleary, and top and came from The Composing Room at Cooper & Beatty. You may notice a resemblance between this piece and our two pages of the 1912 and 1923 American Type Founders books. We decided to celebrate the launch of Berthold into setting of the ATF Cheltenham family by using some of the material that ATF used to publicize this face. We also rather enjoyed a chuckle of a few days via the printer. Some of the prose are the present era, and some are generic. We also found it rather unfair to present Johnson as we've known the present age as we've known previous ads. The quote Cheltenham Italic at the foot is a thought.

EVOLUTION OF THE BOOK AND FINAL DEVELOPMENT

BINDING books carries us back perhaps several thousand years, when very heavy leaden tablets with inscribed hieroglyphics were put together with rings, which formed what we would consider the binding of the volumes. We may go still even farther back, when figures were baked of clay and various cuneiform characters were one within the other, so that if the cover of one were broken or damaged, there still remained another and yet another covering, by which history has been handed down for centuries. Binding in the former would consist of several rings which bound the leaden tablets together, and in the latter the simple and inexpensive covering formed the binding which preserved the contents. We must pass on from there and make another pause, when vellum strips were bound together in one long continuous length with a roller at each end. The reader unrolled the one and rolled the other as he perused the complete book

12 Point Cheltenham Oldstyle
Operated with 1 Point Leads

American
Type Founders

Type Directors Club

Berthold Type Centre

Sponsored again by C&B

February 14th – February 24th

Two Hundred and Sixty King Street East

Open 9:30 am-6:00 pm Daily; until 8:00 pm Wednesdays

The Cheltenham Italic is an excellent face for booklets, menus, and general commercial printing, being especially legible and yet very attractive. Its popularity is constantly growing. Use it on your next booklet or circular and you will surely please your customer

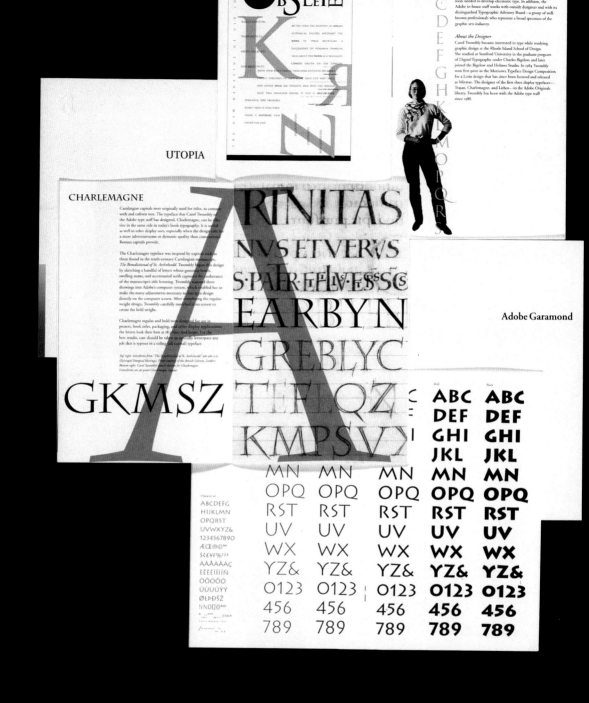

Specimen Books

Typography/Design **Laurie Szujewska, Jack Stauffacher, Min Wang, and Cleo Huggins,** *Mountain View, California*

Typographic supplier **In-house**

Studio **Art Department, Adobe Systems Incorporated**

Client **Adobe Systems Incorporated**

Principal types **Adobe Garamond, Utopia, Lithos, Trajan, and Charlemagne**

Dimensions **5⅝ x 9 in. (14.3 x 22.9 cm)**

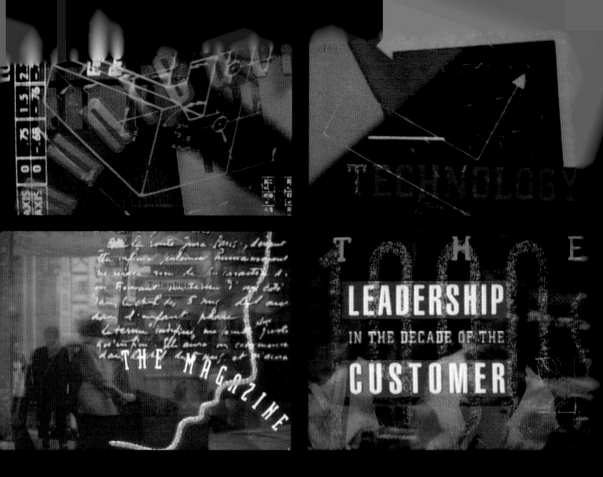

Video
Typography/Design Kent Hunter, Kin Yuen, Saeri Park,
 and Stephen Tasker, *New York, New York*
Animation Nancy Laurence
Production Company Eye Design/Nancy Laurence and Kelly Moseley
Typographic supplier In-house
Agency Frankfurt Gips Balkind
Client MCI Communications Corporation
Principal types Various

Poster
Typography/Design **Katherine McCoy,** *Bloomfield Hills, Michigan*
Typographic supplier **In-house**
Studio **McCoy & McCoy**
Client **Cranbrook Academy of Art**
Principal types **Adobe Franklin Gothic and Futura Extra Bold**

Announcement
Typography/Design **Jeffrey S. Fabian, Jean W. Kane,**
and Samuel G. Shelton, *Washington, D.C.*
Typographic supplier **Composition Systems, Inc.**
Studio **KINETIK Communication Graphics, Inc.**
Client **Art Directors Club of Metropolitan Washington**
Principal types **Univers, Americana, and Futura**
Dimensions **7⅝ x 7⅝ in. (19.4 x 19.4 cm)**

first

The way we look.

The way we act.

The things we say. *("yeah")*

The fact and fiction of how others perceive us

formulates their impressions.

And it's that first contact

the first impression

that often sets the tone for

everything that follows ⇒►

*"It was the Rainbow gave thee birth
And left thee all her lovely hues."*
W. H. Davies: The Kingfisher

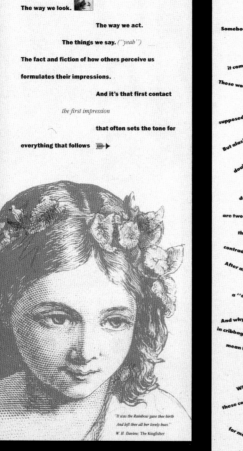

DOUBLE TALK

Somebody has been

double dealing when

it comes to double entendres.

These words or phrases are

supposed to have two meanings.

But alas! We've been

double crossed—deuced even—

by a slew of

double entendres that

are two-faced because

they represent a

contradiction in "two" terms.

After all, how can there be

a "duet for one"? Why does a "two-step" entail three steps?

And why does a "pair royal"

in cribbage and other card games

mean three-of-a-kind?

Who is the culprit behind

these confusing paradoxes?

Stay "two-ned"

for more information.

*Second choice doesn't have to mean second rate. If
you want to create crisper, deeper halftones, con-
sider using duotones. Duotones are two-color
reproductions from a one color photograph. By
using a deep gray or blue, you can intensify the
contrasts between the light and dark areas of your
halftone. Duotones can be produced with any
color; you can communicate a special mood or
effect by using an unusual or bright second color.
So think twice about those halftones!*

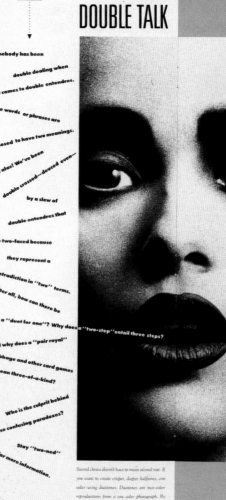

DOUBLE VISION

An eye for an eye for an eye and you're seeing double. *Diplopia* is the technical term for double vision, which is the perception of two images from a single object. It is most commonly caused by temporary or permanent paralysis of the eye muscle and is one of the first signs of botulism and myasthenia gravis (to say nothing of drinking too much!).

However, it's important not to confuse diplopia with other twos of the eyes. For example, you can't use bifocals to correct double vision. Bifocals are eyeglasses with lenses that are split into two. Half the lenses correct for nearsightedness and half correct for farsightedness. Benjamin Franklin was the first to experiment with designing bifocal lenses so that he could glance up from reading and enjoy scenery on trips. But bifocals didn't become popular until the 1820s, when enough people had access to regular glasses that they tired of having to change from reading to distance lenses.

And don't start thinking that if the eye doctor checks your vision twice you've had a double refraction, unless you're Shirley MacLaine. Double refraction is really an optical property of crystals. Also known as birefringence, double refraction occurs when a single ray of light entering a crystal is split into two rays, each travelling in a different direction. One ray, called the extraordinary ray, becomes bent, or refracted. Calcites, ice, mica, quartz, sugar and tourmaline are all examples of crystals that will double refract. Who knows—maybe by playing with double refracting crystals you'll discover a supernatural property that will give you second sight.

TWO WRONGS DO NOT MAKE A RIGHT.

Brochure
Typography/Design **Mark Oldach,** *Chicago, Illinois*
Photographer **David Bentley Photography**
Typographic supplier **The Typecasters**
Studio **Mark Oldach Design**
Client **First Impression Printers and Lithographers**
Principal types **Univers 49, Futura Extra Bold, and Sabon**

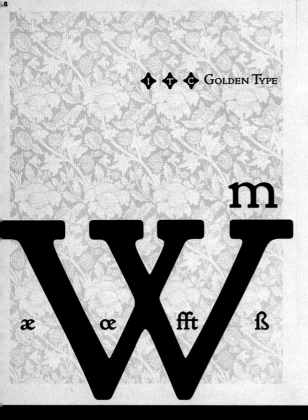

◆ T ◆ GOLDEN TYPE

m
æ œ **W** fft ß

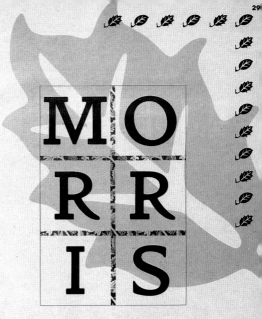

MO
RR
IS

&?!()$¢£%/#1234567890

Magazine Spread
Typography/Design **Weisz, Yang, Dunkelberger, Inc.,**
Westport, Connecticut
Typographic supplier **Characters Typographic Services, Inc.**
Studio **Weisz, Yang, Dunkelberger, Inc.**
Client **U&lc for International Typeface Corporation**
Principal type **ITC Golden Type**
Dimensions **22 x 14¾ in. (55.9 x 37.5 cm)**

THE LIFE AND TYPE

of

GIAMBATTISTA

BODONI

Brochure
Typography/Design Tim Girvin and Stephen Pannone,
Seattle, Washington
Calligrapher Tim Girvin
Letterers Anton Kimball and Stephen Pannone
Typographic supplier In-house
Studio Tim Girvin Design, Inc.
Client Simpson Paper Company
Principal types Bodoni Book and handlettering
Dimensions 8½ x 12 in. (21.6 x 30.5 cm)

Brochure
Typography/Design Leah Toby Hoffmitz and Terry Irwin, *Los Angeles, California*
Art Director Leah Toby Hoffmitz
Typographic supplier Andresen Typographics and Characters and Color
Client Characters and Color
Principal types Various
Dimensions 14 x 12¼ in. (35.6 x 31.1 cm)

NINETEENTH-CENTURY
JOB PRINTING
Display

THE
POSTER.

Bowne & Co., Stationers
SOUTH STREET SEAPORT MUSEUM
1989

SOME
RULES
FOR
BROADSIDE
COMPOSITION

Book Cover Series
Typography/Design **Marc J. Cohen,** *Maplewood, New Jersey*
Art Director **Susan Mitchell,** *Stamford, Connecticut*
Typographic supplier **Maxwell Typographers**
Client **Vintage Books**
Principal types **Various**
Dimensions **5³⁄₁₆ x 8 in. (13.2 x 20.3 cm)**

THE DISTINGUISHED SCIENTIST SCHOLARS PROGRAM

The Distinguished Scientist Lecture Series

BARD
A College of the Liberal Arts and Sciences

Held during the summer months in two sessions
First session:
June 24 – July 20, 1990
Second session:
July 30 – Aug. 24, 1990

▷ *Human wants and*

environmental needs

have come into

conflict throughout

civilization.

Bard's unique

interdisciplinary

program is committed

to training the

professionals who

will one day resolve

The Master

BARD
A College of the Liberal Arts and Sciences

Poster
Typography/Design Clifford Stoltze and Terry Swack,
Boston, Massachusetts
Typographic supplier In-house
Studios Clifford Stoltze Design and Terry Swack Design Associates
Client Boston AIGA
Principal types Oakland Six and Franklin Gothic
Dimensions 48 x 33 in. (121.9 x 83.8 cm)

BROKEN YOYO

Album Cover
Typography/Design James A. Houff, *Grosse Point, Michigan*
Letterer James A. Houff
Typographic supplier In-house
Studio James A. Houff Design
Client FIASCO RECORDS
Principal types Clarendon and handlettering
Dimensions 12¼ x 12¼ in. (31.1 x 31.1 cm)

Poster
Typography/Design **Clifford Stoltze and Rick Stermole,**
Boston, Massachusetts
Typographic supplier **In-house**
Studio **Clifford Stoltze Design**
Client **Boston AIGA**
Principal types **Modula Serif, Oblong, and Variex**
Dimensions **24 x 34 in. (61 x 86.4 cm)**

Poster
Typography/Design **Haley Johnson,** *Minneapolis, Minnesota*
Letterer **Lynn Schulte**
Typographic supplier **LinoTypographers,** *Fort Worth, Texas*
Studio **The Duffy Design Group**
Client **Williamson Printing Company**
Principal types **Coronet Bold, Venus Bold Extended, Kaufman Bold, and handlettering**
Dimensions **21 x 33½ in. (53.3 x 85.1 cm)**

Poster

Typography/Design Jennifer Morla and Marianne Mitten,
San Francisco, California

Calligrapher Jennifer Morla

Typographic supplier Spartan Typographers

Studio Morla Design, Inc.

Client Stanford Alumni Association

Vive La

It's 1989, and France is holding court with a bicentennial fête and more birthday cake than Marie Antoinette could shake a royal whisk at. From the country that gave us bistro, bustier, beau monde and brasserie. Where Jacques and Jill go up the hill to fetch a rare Bordeaux. It's pyramid power, s'il vous plaît. Where four francs buy a baguette. And fifty buy a balcony seat. Where fashion got haute. And furniture got a gilt complex. Now Bloomingdale's-as-ambassador brings it all home. From our maison to yours. With a tip of our beret and a toast of Beaujolais. Vive la France!

france

Campaign
Typography/Design **Robert Valentine,**
New York, New York
Calligrapher **Robert Valentine**
Typographic supplier **Boro Typographers**
Agency **Bloomingdale's Special Projects**
Client **Bloomingdale's**
Principal type **Handlettering**

DANDY & FINE

Accent to Ascent

(1940—)

Correspondence
on the Occasions of
Work Published
in Literary Magazines
at the University
of Illinois

Mac Briskin ● Daniel Curley ● William H. Gass ● George Mills ● Katherine Anne Porter ● Wallace Stevens
E.E. Cummings ● Brendan Galvin ● Bobbie Ann Mason ● Flannery O'Connor ● J.F. Powers ● Eudora Welty

University of Illinois at Urbana-Champaign

Brendan Galvin

(1938—)

Dear Dan, Enclosed is a longish poem of mine, "Snakebit," which I hope might interest you for ASCENT. ● Also, enclosed are six by a retired anthropology prof who was in my seminar on Martha's Vineyard last July. He's been writing for 5 or 6 years, and I think he's good. He's been shy of sending stuff out, so I told him I'd try to get some poems around for him. If you're interested, you can let him know. If not, please send them back to me. ● Not much new here. Conn Public TV is doing a "poetry video" of one of my poems this week, and will use it as filler for these 50-minute programs they have. This should send the first stone crashing through a window here soon. A poetry video? ● Miles sends her best, as do I. We hope Audrey is feeling better, and that you're well. All best, November 11, 1986. Dear Brendan: Many thanks for the rich submission. Audrey and I both like SNAKEBIT. I can't say when I'll use it, perhaps not before next fall. But ... whenever I use it it will be eligible for the prize. Money for paying contributors is another problem—ASA will probably not give more money for such frivolity. We hope, however. ● George Mills is a real find. I'm going to write his about a couple of his poems and will wind up taking one or both. When I've tried to help people by sending things around, I've met with pretty cold responses; let his send his own. I'm glad you did it and doubly glad that I can show appreciation in the appropriate way. ● Audrey comes on very well, thank you. NPPWT will be out in February. I try not to think about it. Best to Ellen and all the bears.

Poet Brendan Galvin has successfully melded a variety of styles, influences, and interests. Impossible to categorize, Galvin has engaged a wide range of subject matter: life in New England (especially his first two collections, *The Narrow Land* and *The Salt Farm*); nature studies (especially the powerful *Atlantic Flyway*, in which Galvin forms on the birds indigenous to his homeland); the complications of time and change in a modern urbanized society; the dangers awaiting today's youth. His mature work shows influences ranging from Robert Frost and Robert Lowell to Theodore Roethke; more important, Galvin's unique realistic vision, coupled with an engaging sense of humor, allows him to transcend these sources. ● Galvin has published extensively in *Ascent*. His contributions include "Snakebit," "The Freeloater," "Shoveling Out," "Just in Case You're Wondering Who You Are," "A Few Words from the Weeds," "Edge," "An-gel," and "Finbacks." ● In addition to his poetry and various well-received and influential critical pieces, Galvin has dedicated a good deal of his life energy to encouraging other poets, young and old.

No Time for Good Reasons

Atlantic Flyway

Wampanog Traveller

Seals in the Inner Harbor

Winter Oysters

Snakebit
(1767)

George Mills

(1949—)

Brendan Galvin's contribution went beyond his own work, for it was Galvin who brought the work of George Mills to Dan Curley's attention. The secondhand introduction proved to be fruitful for both Mills and *Ascent*. Mills won the *Ascent* poetry prize for 1988 for "Empery" and "Quite a Guy." He wrote the accompanying letter sometime in 1988 after learning of the award. Mills read from his poetry at the awards ceremonies in October of 1988 and wrote to Dan and Audrey Curley on October 13: "You did such a great job of honoring, who knows, I may have developed a taste for it."

Dear Dan,

I haven't forgotten.

I remember reading Thanatopsis at an early age & being carried away. I had to share it with someone, so I read it aloud to my father, a businessman & musician. I majored in English Lit. at Dartmouth but got the impression that literature was to be studied, not written. Couldn't imagine how the things I studied ever got churned out. Still have trouble with some of them. Graduated into WW II which put off deciding on a career. When further postponement became impossible, I thought that Grad graduate work in literature would leave me no choice but teaching & not wanting to do that, I went into cultural anthropology instead—and ended up teaching. I was such a good teacher I talked myself out of anthropology, left academia & did physical labor of one sort or another until I retired. Helped tie & water a printing press, worked for a pipe organ builder, dug some holes for a landscaper. Retirement gave me the time to do something about my need to write. Or write regularly. Or write seriously. I have always been filling up notebooks but didn't begin to like the results until six or so years ago. I published my first poem many years ago in the Colorado Quarterly. It repeats I make the mistake of trying to impress by sounding singular makes intel. I've had spurts of sending things around since, as you know, Brendan Galvin tried to kick me in the ass. With his prodding, I have appeared in Calliope, Poet Lore, Poultry. I also have stuff in Stone Country & a publication called Island. I find that I'd rather write than keep books. Besides, I have faith in a poem's ability to find its own way in the world.

Hope this is of some use.

Empery

The Queen's horse,
when it poops,
opens like a timelapse rose.

On almost any day her African sunlight
spreads itself
& pours out fame.

She has a house snake
for thinking thoughts;
for and the human mind.

Or take her pet ostrich:
its eyeballs
weigh more than its brain.

Regardant
is full
of uncut diamonds.

That goat circling
the expansive cave
is half man—

Yes, & royal admiration notes
the longevity
of the erection.

And then one day—
most precious
of all—

The Queen's puppy
comes out from under
her skirt.

Sits whimpering between
her body
& her severed head.

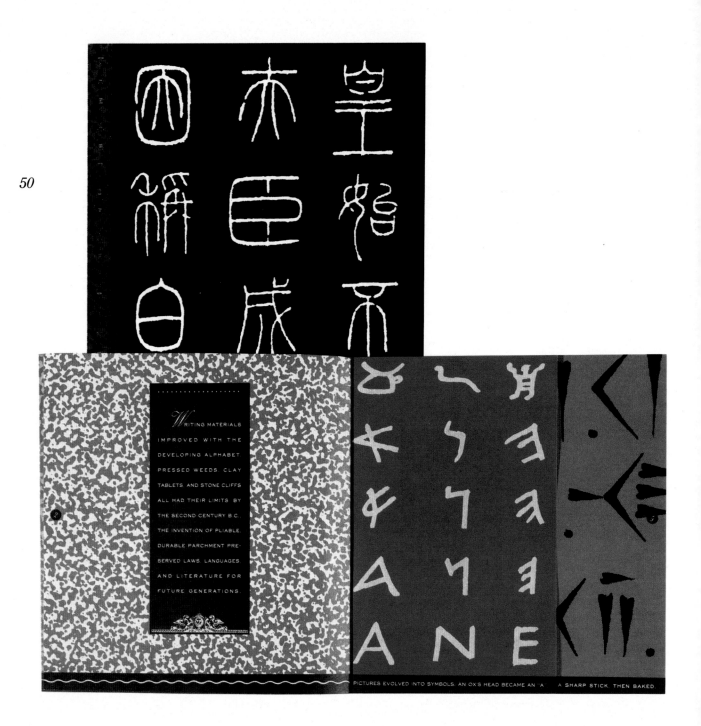

50

Promotion
Typography/Design Jennifer Morla and Jeannette Aramburu,
San Francisco, California
Typographic supplier Andresen Typographics
Studio Morla Design, Inc.
Client Simpson Paper
Principal type Six-Line Block Gothic
Dimensions 6¼ x 6¼ in. (15.9 x 15.9 cm)

Campaign
Typography/Design **Sharon Werner and Haley Johnson,**
Minneapolis, Minnesota
Letterer **Lynn Schulte**
Typographic suppliers **TypeShooters and Typemasters**
Studio **The Duffy Design Group**
Client **D'Amico & Partners**
Principal types **Spartan, Diskus, and handlettering**

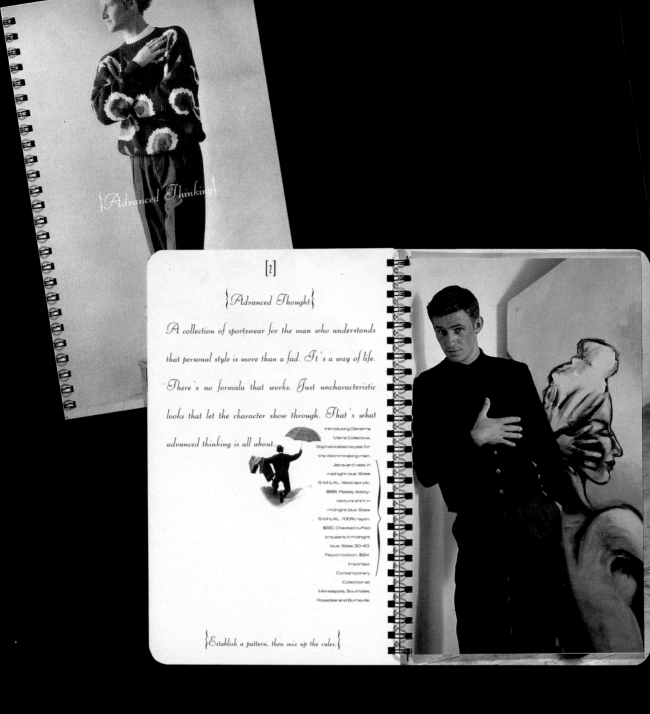

[2]

{Advanced Thought}

A collection of sportswear for the man who understands that personal style is more than a fad. It's a way of life. There's no formula that works. Just uncharacteristic looks that let the character show through. That's what advanced thinking is all about.

Introducing Generra Men's Collective. Sophisticated styles for the discriminating man. Jacquard vest in midnight blue. Sizes S-M-L-XL. Wool/acrylic. $68. Paisley dobby-texture shirt in midnight blue. Sizes S-M-L-XL. 100% rayon. $90. Checked cuffed trousers in midnight blue. Sizes 30-40. Rayon/cotton. $84. Imported. Contemporary Collection at Minneapolis, Southdale, Rosedale and Burnsville.

{Establish a pattern, then mix up the rules.}

{Advanced Thinking}

Mailer
Typography/Design Cheryl Watson, *Minneapolis, Minnesota*
Typographic supplier In-house
Studio Dayton Hudson
Client Dayton Hudson Department Store Co.
Principal types Liberty and Microstyle Extended
Dimensions 5½ x 9 in. (14 x 22.9 cm)

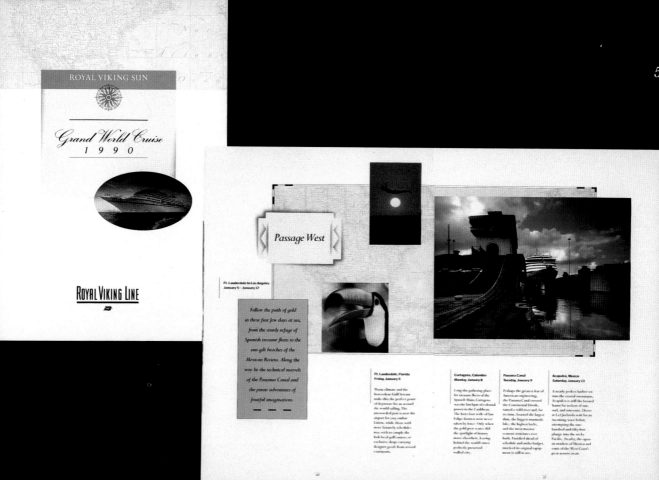

Brochure
Typography/Design **Lucille Tenazas,** *San Francisco, California*
Typographic suppliers **Rapid Typographers and Andresen Typographics**
Studio **Tenazas Design**
Client **Royal Viking Line**
Principal type **Perpetua**
Dimensions **11¼ x 7¾ in. (28.6 x 19.7 cm)**

When the worked-out cotton fields of the South were abandoned late in the 19th century, many reverted to pine forests. Today this "old field pine" represents one of the richest and fastest growing sources of softwood timber in the country. Loblolly is the most prevalent of two southern yellow pine species that flourish on Potlatch forestland in southern Arkansas.

With a name meaning "muddy puddle" or "bubbling broth," loblolly favors moist habitat. Mild temperatures, abundant rainfall and fertile soil in Arkansas' upland terraces create an environment conducive to loblolly pine's vigorous growth. On Potlatch plantations, loblolly can be harvested for sawlogs in about 35 years.

The tree has a tendency to prune itself as it grows, leaving long, clean stems. Compared to northern conifers which experience longer winter rest periods, loblolly generally has more uniform annual rings and is coarser grained.

In Arkansas, Potlatch manufactures pine into boards, framing lumber and chips, as well as a wide range of laminated and millwork products. Wood residues such as slabs and edge trimmings also are converted to chips for making bleached pulp and paperboard.

Since the mid-1970s, our southern division has operated an extensive tree breeding program, focused on developing genetically superior loblolly that provide improved quality and quantity, and help to ensure a continuous supply of this resource.

Loblolly cones grow to about 6 inches in length and produce seeds with ½-inch wings.

Loblolly is converted into a variety of lumber and specialty wood products.

8

Annual Report
Typography/Design **Kit Hinrichs and Terri Driscoll,**
San Francisco, California
Art Director **Kit Hinrichs**
Typographic supplier **Spartan Typographers**

It takes most hotels

decades to create a legend. ♦ The Little Nell

already has one. ♦ It begins on Saturday, August 13, 1881. ♦

The day *The Aspen Times* recorded the mining claim of

D.D. Fowler. ♦ To a mine he first called, "The Little Nellie." ♦

Located on the Eastern side of Aspen Hill—

just up the slope, in fact, from where the hotel stands today

—the mine ran over 70 feet into the mountain and

dropped more than 65 feet in depth. ♦ Of course,

there were hundreds of other mines scattered on the slopes

above town —the Little Emma, the Little Daisy,

the Little Jennie, and even the Little Dudley. ♦ But there

was only one named The Little Nell. ♦ For that's what

they called it in 1885, when it was joined to the Chance and

Enterprise tunnels nearby. ♦

Brochure
Art Director Kit Hinrichs, *San Francisco, California*
Designer Susie Leversee
Typographic supplier Andresen Typographics
Studio Pentagram Design
Client Aspen Skiing Company
Principal type Weiss
Dimensions 4 x 6 in. (10.2 x 15.2 cm)

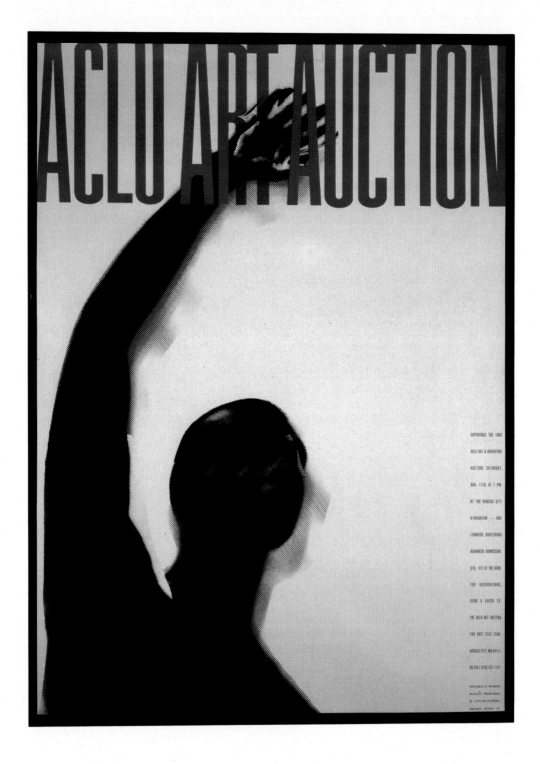

Poster
Typography/Design **Jane Weeks and John Muller,**
 Kansas City, Missouri
Letterer **Jane Weeks**
Typographic supplier **Cicero Typographers**
Studio **Muller & Company**
Client **Kansas City Chapter of the American Civil Liberties Union**
Principal types **Univers 49, handcut, and handlettering**
Dimensions **30¾ x 43¼ in. (78.1 x 109.9 cm)**

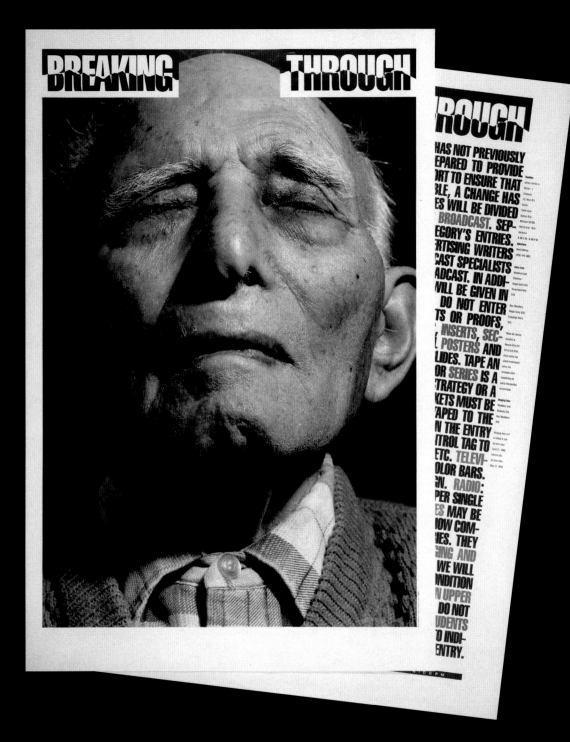

Announcement
Typography/Design **John Muller, Patrice Eilts, and Jane Weeks,**
Kansas City, Missouri
Letterers **Patrice Eilts, Jane Weeks, Scott Chapman, and John Muller**
Typographic supplier **Fontastik Typographers**
Studio **Muller & Company**
Client **Kansas City Art Directors Club**
Principal types **Aura, Copperplate, and handlettering**
Dimensions **22½ x 35 in. (57.2 x 88.9 cm)**

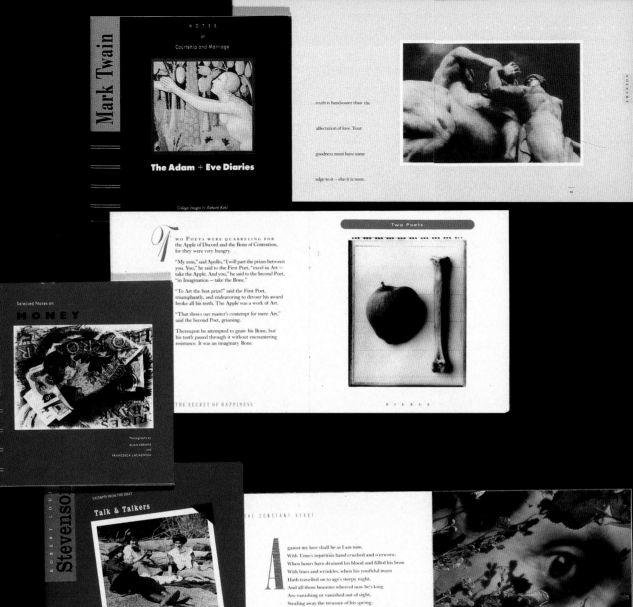

Book

Typography/Design **Christopher Ozubko, Jo Ann Sire, John Linse, and Susan Ozubko,** *Seattle, Washington*

Photographers **Tom Collicot, M. P. Curtis, Robin Bartholick, Richard Kehl, Jill Sabella, Thom Sempere, Alan Abrams, and Francesa Lacagnina**

Editors **Jana Stone and Roy Finamore**

Typographic suppliers **Art-Foto and Western Type**

Studio **OZUBKO Communication + Design Consultants**

Client **Stewart, Tabori & Chang**

Principal types **Various**

Dimensions **5¼ x 5¼ in. (13.3 x 13.3 cm)**

I remember the Saturday
well. The phone rang—
two longs and a short on
the party line—just
before dinner. He had to
make a house call. I
asked to tag along for the
ride. "Don't dawdle, my
boy. Mustn't keep the patient
waiting," he asserted in
his usual steadfast manner.
Off we sped.

"I don't need this shit!" says *USA Today* gossip columnist Jeannie Williams. It's the morning of May 19th, and Williams has just seen the breakfast press screening of *Do the Right Thing* at the Cannes film festival. Tonight, the film will have its black-tie, red-carpet gala première at the Palais des Festivals, on the Côte d'Azur beach, where it will be competing with films from around the world for the coveted Palm d'Or prize. This morning, the more modest Palais press-confer-

Director Spike Lee's

'Do the Right Thing' Takes a

Provocative Look at Race Relations

By David Handelman

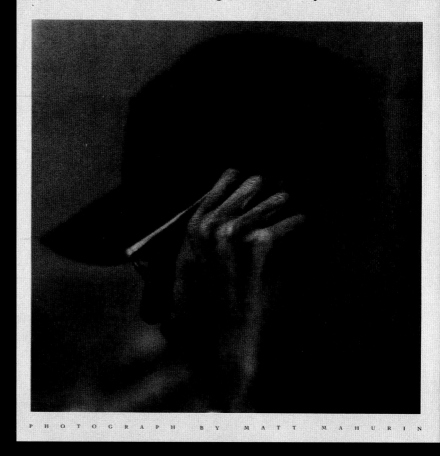

P H O T O G R A P H B Y M A T T M A H U R I N

Magazine Spread
Typography/Design **Gail Anderson,** *New York, New York*
Typographic supplier **In-house**
Studio **Rolling Stone**
Client **Rolling Stone**
Principal types **Nubian and Cochin**
Dimensions **12 x 20 in. (30.50 x 50.8 cm)**

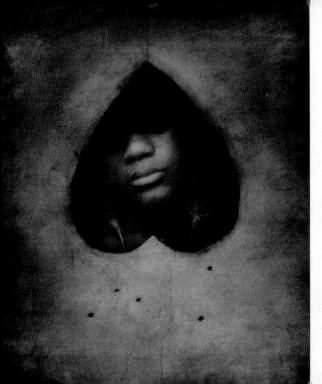

Terrorized by her husband's repeated death threats, Renee Linton did everything women are supposed to do to protect themselves under the system. Yet despite her calls for help, her court order of protection, her flights ‹Nowhere to Run› to a shelter for battered women, the system failed to save her.

By Ellen Hopkins

PHOTOGRAPH BY MATT MAHURIN

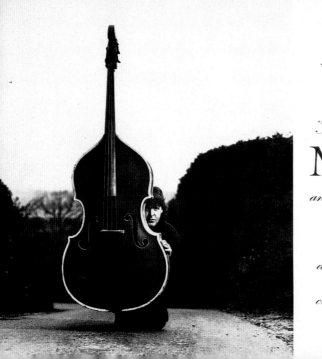

He hasn't **CAN** had a big hit album in years. The other Beatles are suing him. **PAUL** But with 'Flowers in the Dirt,' his strong new record, **McCARTNEY** and plans for his first world tour in more than a decade, the **GET** ex-Beatle is doing his best to toughen up his image and climb back **BACK?** to the top.

BY JAMES HENKE

For Mark Kilroy and his friends, the night-mare began as a spring-break blossom. In the early hours of Saturday, March 11th, Kilroy, a senior at the University of Texas at Austin, Bill Huddleston and Bradley Moore, both juniors at Texas A&M, and Brent Martin, a student at Alvin Community College, in Alvin, Texas, packed into Martin's car and hit the road bound for South Padre Island, a balmy stretch of sand and sea where the southern tip of the Lone Star State meets the Gulf of Mexico. The quartet – all former high-school basketball and baseball teammates from Santa Fe, Texas – were looking forward to a week of drinking, tanning and meeting girls on the beach. Blond and well built, a pressed and a good athlete, Kilroy, 21, was the all-American boy next door, described by one of his friends as "an above-average kind of guy."

On Sunday the four youths decided to make a short trip to nearby Brownsville and then cross the Rio Grande to Matamoros, a scrappy, bustling border town whose main attraction to thousands of spring-break students each year is Calle Alvaro Obregon, a wide avenue of bars and discos where you can get a cold Corona with lime for a dollar. Along the way the friends stopped at a hamburger joint and hooked up with a foursome of Kansas coeds who were looking for directions to Matamoros. Once across the border, they rendezvoused with their dates at a club called Sgt. Pepper's. "The line outside wasn't too bad," says Huddleston, "but it was pretty crowded." The boys drank and danced until about 2:30 a.m., then headed back to their hotel.

The following night, after dropping in at a party thrown by some of Kilroy's fraternity brothers, he and his friends decided to pay a second visit to Matamoros. This time, though, they parked their car on the American side of the border and walked across the bridge to Calle Obregon. The first stop was El Sombrero, where they had a couple of drinks before moving a few blocks farther down the street to a joint that had recently been rechristened the Hard Rock, to attract American kids. There Mark left the group to

talk to a woman that he knew. "Mark was hanging around with a girl who got third place in the tanning contest," says Huddleston. Eventually, Kilroy said goodnight to his female friend, and the four youths started walking back toward the bridge. Spirits were high as the friends traded banter about the day's events. About 200 feet from the American border, Huddleston ran ahead to urinate behind a tree in the small park that lies at the beginning of Calle Obregon.

As he left Kilroy's side, Huddleston noticed a Mexican man motioning in their direction. "I thought maybe it was someone Mark might've known," says Huddleston. "I heard him say something like 'Didn't I just see you somewhere?' or 'Where did I last see you?'" When Huddleston joined Moore and Martin a few moments later, Kilroy wasn't with them. After backtracking to look for his friend, Huddleston crossed the border, expecting to find Kilroy at the car with Moore and Martin. The trio waited a few more minutes, then left, thinking that Kilroy had gotten a ride back to the hotel with somebody else. Says Huddleston, "When we woke up the next morning and we still hadn't heard from him, that's when we knew something was wrong."

The search for Mark Kilroy started as a routine missing-persons case. Students were often reported missing in Matamoros, only to turn up the next day with a ferocious hangover and no memory of the night before. But it soon became clear that Mark's case was different. Authorities on both sides of the Rio Grande suspected foul play, but the police were short on leads. Donald Wells, the U.S. consul in Matamoros, was contacted, and a description of Kilroy was circulated in jails and hospitals. Two days later investigators called in a hypnotist in the hope of turning up some clues. Under hypnosis, Moore told police that he had last seen Kilroy talking to a young Hispanic man with a cut on his face.

Meanwhile, Mark's parents, James and Helen Kilroy, flew to Brownsville to lead the search. Over the next few weeks the Kilroys mounted a determined campaign to locate their son. They circulated 20,000

THE BELIEVERS

By *Guy Garcia*

THEY THOUGHT THEIR
RITUALS OF HUMAN
SACRIFICE WOULD
MAKE THEM INVIN-
CIBLE. IN THE END,
A MUCH STRONGER
FORCE PREVAILED.

i l l u s t r a t i o n

BY SUE COE

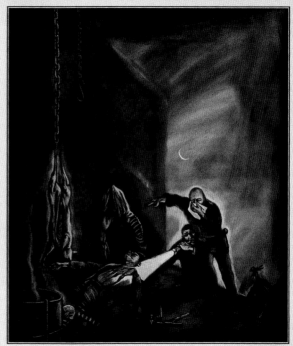

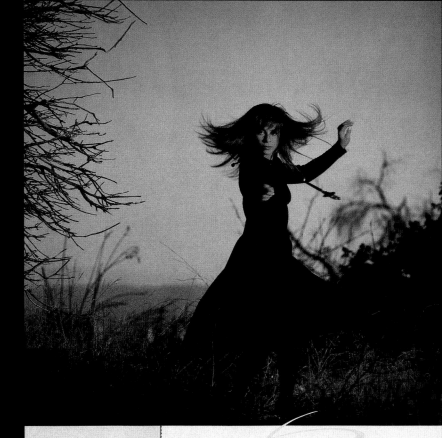

PAULA ABDUL
CHOREOGRAPHS
HER WAY
TO THE TOP

*O*MIGOD, NNNOOOO!!!"
The tremendous, high-pitched squeal that fills the tastefully appointed Beverly Hills conference room comes from a petite, black-clad figure curled up on a company couch. It's Paula Abdul, the singer-dancer-choreographer who's spending a rare reclining moment watching a few video images of herself as a Los Angeles Lakers cheerleader sporting an early-Eighties haircut from hell.

Abdul has taken time out of her hyperhectic schedule to stop by the Virgin Records offices to check out a rough cut of an upcoming piece of Paula product – a video compilation called *Paula Abdul: Straight Up*. Before she arrived in her black Jaguar at ten o'clock this morning, Abdul had already sat for a two-hour interview and taken an encouraging meeting with 20th Century Fox executives to discuss her acting career. Later, she will attend a planning session for her second album, meet the press once again, rehearse a dance troupe for

ALL THE RIGHT MOVES

BY DAVID WILD

PHOTOGRAPHS BY TIMOTHY WHITE

Magazine Spread
Typography/Design **Debra Bishop,** *New York, New York*
Typographic supplier **In-house**
Studio **Rolling Stone**
Client **Rolling Stone**
Principal type **Deroos Inline**
Dimensions **12 x 20 in. (30.5 x 50.8 cm)**

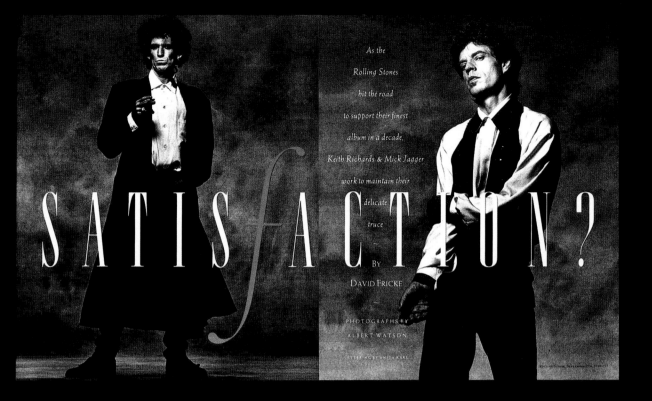

As the Rolling Stones hit the road to support their finest album in a decade, Keith Richards & Mick Jagger work to maintain their delicate truce

SATIS*f*ACTION?

BY DAVID FRICKE

PHOTOGRAPHS BY ALBERT WATSON

LETTERING BY ANITA KARL

Magazine Spread
Typography/Design Cathy Gilmore-Barnes,
New York, New York
Letterer Anita Karl
Typographic supplier In-house
Studio Rolling Stone
Client Rolling Stone
Principal type Spire
Dimensions 12 x 20 in. (30.5 x 50.8 cm)

Catalog
Typography/Design **Steven Tolleson and Renee Sullivan,**
San Francisco, California
Typographic suppliers **Spartan Typographers and EuroType**
Studio **Tolleson Design**
Client **Society Expeditions Cruises**
Principal types **Garamond No. 3 and Kabel**
Dimensions **8 x 11 in. (20.3 x 27.9 cm)**

Annual Report

Typography/Design John Van Dyke, *Seattle, Washington*

Typographic supplier In-house

Agency Van Dyke Company

Client Expeditors International

Principal type Univers 75

Dimensions 8¼ x 11¾ in. (21 x 29.8 cm)

CHAIRMAN AND CEO *Kemper Re's very positive outlook on the future is supported by its demonstrated ability to deal constructively with a wide variety of new and challenges over the last twenty years. Kemper Re's successful growth has been shaped and guided by a management team and staff with their commitment and a high degree of continuity and stability. This has been the key to the success of the enterprise as a whole. There can be no question that real opportunities lie ahead for a company which enjoys so many fundamental strengths as Kemper Re.* **DAVID B. MATHIS**

CHAIRMAN'S LETTER FOR THE THIRD CONSECUTIVE YEAR, KEMPER RE-INSURANCE COMPANY POSTED RECORD OPERATING EARNINGS IN 1988. LOWER SALES DURING THE YEAR REFLECTED OUR DETERMINATION TO MAINTAIN HIGH UNDER-WRITING STANDARDS IN THE FACE OF A SOFTENING MARKET AND DECLINING DEMAND. ALSO CONTRIBUTING TO OUR SUCCESS WAS THE ABSENCE OF MAJOR INSURED CATASTROPHES INVOLVING REINSURANCE AND THE ON-GOING BENEFITS OF OUR CONTINUED CAREFUL CONTROL OF EXPENSES.

OPERATING EARNINGS IN 1988 WERE $52.9 MILLION VERSUS $50.5 MILLION IN 1987, AN INCREASE OF 4.7 PERCENT. SALES DECLINED 20.6 PERCENT FROM $388.8 MILLION IN 1987 TO $308.9 MILLION IN 1988. EARNINGS IN 1988 INCLUDE A "FRESH START" BENEFIT OF $6.5 MILLION DUE TO THE TAX REFORM ACT OF 1986, COMPARED TO $13.8 MILLION IN 1987. IT'S WORTH NOTING THAT IF THESE "FRESH START" BENEFITS WERE DISREGARDED, THE 1988 OPERATING EARNINGS WOULD REPRESENT A 26 PERCENT INCREASE OVER THE LEVEL OF THE PREVIOUS YEAR.

WHILE IT IS GRATIFYING THAT OUR STRATEGIES ARE WORKING TO PRODUCE EXCELLENT PROFITS, OUR PLANNING FOR THE FUTURE MUST INCLUDE A CAREFUL ANALYSIS OF THE CAUSES OF THE DECLINE IN SALES, WHICH IS A FUNCTION OF THE REINSURANCE CYCLE.

WHERE WE ARE IN THE CYCLE IN REINSURANCE, CYCLES ARE RE-OCCUR-RING BUT NOT NECESSARILY REGULAR. EXTERNALITIES SUCH AS INTEREST RATE LEVELS, NATURAL CATASTROPHES, RAPID TECHNOLOGICAL INNOVATION, POLITICAL CHANGE AND NEW CONCEPTS OF LIABILITY BEND AND TWIST THE TRAJECTORY OF THE CYCLE. ON A MORE FUNDAMENTAL LEVEL, THE CYCLE IS DRIVEN BY THE INABILITY OF BUYERS AND SELLERS TO REACT IN THE PRECISELY RIGHT WAY TO THESE VARIABLES. IT SEEMS THERE IS ALWAYS OVERREACTION IN ONE DIRECTION OR THE OTHER.

We are pleased to report that Fiscal 1988 was the third consecutive year of earnings growth for Reeves.

More importantly, we believe that 1988 marks a significant breakthrough for

Reeves with regard to the scope of the television programming which we have

produced. ■Net income increased to $8,326,000 or $.65 per share, from $6,423,000 or $.51 per share,

THE AWARD WINNING "KATE & ALLIE",

in 1987. Revenues increased from $70,575,000, in Fiscal 1987, to $105,530,000. This higher level of

STARRING SUSAN SAINT JAMES AND JANE

revenues reflects the recognition of a large initial syndication sale of 100 episodes of "Kate & Allie",

CURTIN, IS NOW IN ITS SIXTH ORIGINAL

 our highly successful on-going television series. ■October

SEASON ON CBS WHILE THE 100 COMPLETED

1988, marked the first showing of "Kate & Allie" in syndication.

EPISODES RUN IN SYNDICATION.

We are delighted to report that the rating success achieved in its initial outings on the CBS Tele-

vision Network has carried over into the syndication marketplace. Of course, "Kate & Allie" continues

on CBS in prime-time with new episodes reflecting the network's renewal for the 1988-89 season.

This year the series will feature new and exciting developments—including Allie's (Jane Curtin) wedding!

■Reeves has established itself as a major supplier of network prime-time television programming with

particular emphasis on comedy series such as "Kate & Allie" and "Gimme A Break" (which ran on NBC for

six years). In recognition of this expertise, we currently have

firm commitments for three new series. Production has begun on

"A Doc's Life" for CBS which will air early in 1989 with an initial order of six episodes. We have

AFTER SIX YEARS ON THE NBC TELEVI-

begun the development of two new series ordered by ABC—each with an initial commitment of thirteen

SION NETWORK, THE 137 EPISODES OF

episodes. The first will be created and produced by Michael Leeson (a creator of "The Cosby Show") and

THE HIT COMEDY SERIES "GIMME A

the other is being developed by Mike Nichols. ■Another successful arena for Reeves has been the

BREAK", STARRING NELL CARTER, ARE

development and production of reality-based programming. Among our past accomplishments are the series,

NOW RUNNING IN SYNDICATION.

"In Search of...", "That's Incredible!", "Those Amazing Animals", and network-

Annual Report
Typography/Design **David Suh,** *New York, New York*
Typographic supplier **In-house**
Agency **Frankfurt Gips Balkind**
Client **Reeves Communications Corporation**
Principal type **Letter Gothic**
Dimensions **9 x 11¾ in. (22.9 x 29.8 cm)**

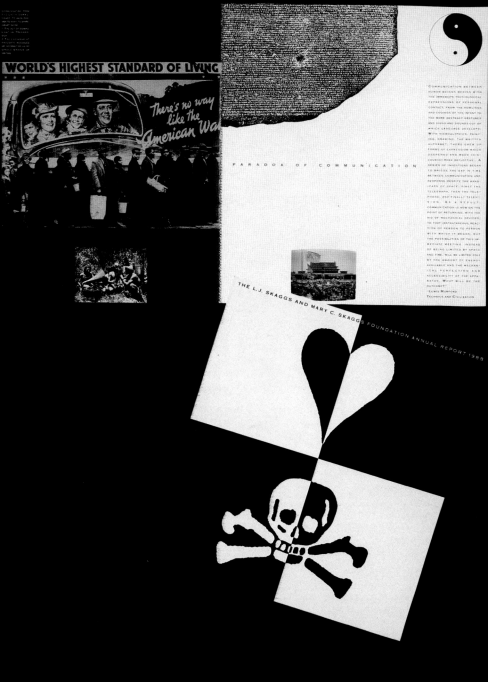

Brochure
Typography/Design Michael Vanderbyl,
San Francisco, California
Typographic supplier Andresen Typographics
Studio Michael Vanderbyl Design
Client The L. J. Skaggs and Mary C. Skaggs Foundation
Principal type Copperplate Gothic
Dimensions 9½ x 8¼ in. (24.1 x 21 cm)

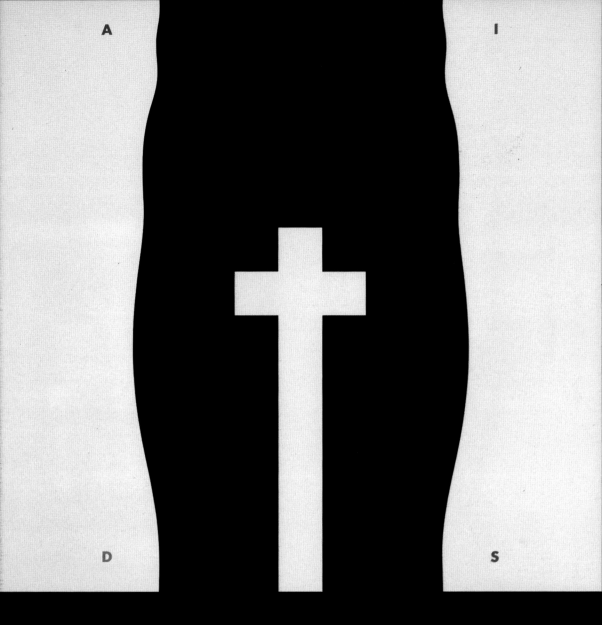

A I

D S

Poster
Typography/Design **McRay Magleby,** *Provo, Utah*
Typographic supplier **In-house**
Studio **BYU Graphics**
Client **Shoshin Society**
Principal type **Futura Bold**
Dimensions **26 x 26 in. (66 x 66 cm)**

KANE

Brochure
Typography/Design **Michael Vanderbyl,**
San Francisco, California
Photographer **Thomas Heinser Studio**
Typographic supplier **Andresen Typographics**
Studio **Michael Vanderbyl Design**
Client **Bernhardt Furniture Company**
Principal type **Copperplate Gothic**

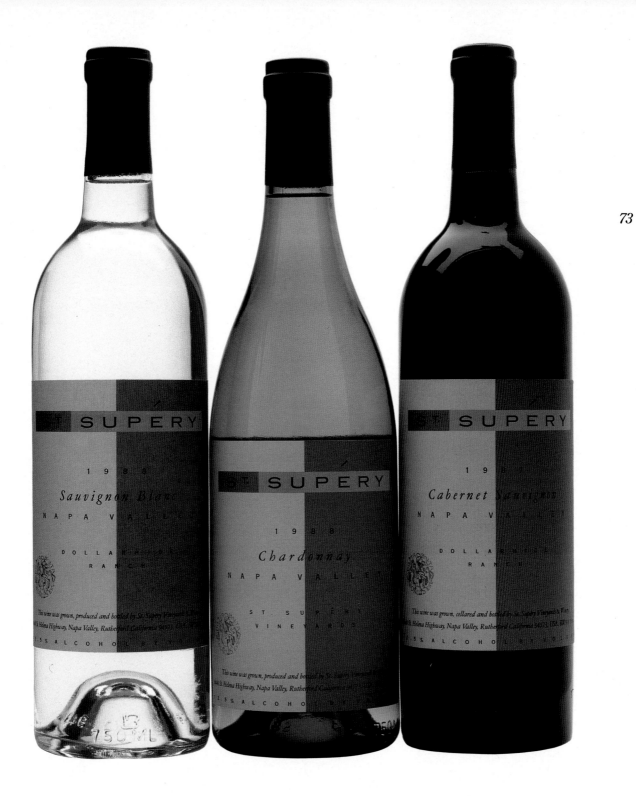

Packaging
Typography/Design **Melanie Doherty,**
San Francisco, California
Typographic suppliers **M & H Type and EuroType**
Studio **Melanie Doherty Design**
Client **St. Supéry Vineyards & Winery**
Principal types **Garamond Italic and Copperplate Gothic**
Dimensions **4⁵⁄₁₆ x 4³⁄₈ in. (10.9 x 11.1 cm)**

MINNE-
APOLIS
COLLEGE
OF ART &
DESIGN
2400 3RD
AVENUE
SOUTH
MINNE-

Stationery
Typography/Design Charles S. Anderson and Dan Olson,
Minneapolis, Minnesota
Letterers Charles S. Anderson, Dan Olson, and Randall Dahlk
Typographic supplier LinoTypographers, *Fort Worth, Texas*
Studio Charles S. Anderson Design Company
Client Minneapolis College of Art and Design
Principal types Futura Light (metal) and handlettering
Dimensions 8½ x 11 in. (21.6 x 27.9 cm)

Stationery
Typography/Design Dennis Crowe and Neal Zimmermann,
San Francisco, California
Typographic suppliers Solotype, Mastertype, and EuroType
Studio Zimmermann Crowe Design
Client Zimmermann Crowe Design
Principal types Rawley Gothic (modified) and Univers 63
Dimensions 8½ x 11 in. (21.6 x 27.9 cm)

NAPA VALLEY

CABERNET SAUVIGNON

1987

RESERVE

UNFILTERED

ROBERT MONDAVI WINERY

ALCOHOL 12.5% BY VOLUME

Packaging
Typography/Design Patti Britton and Susan Pate,
San Francisco, California
Typographic supplier Petrographics Typeworld
Studio Pate International/The Studio
Client Robert Mondavi Winery
Principal type Goudy Old Style
Dimensions 4¾ x 4¾ in. (12.1 x 12.1 cm)

Brochure
Typography/Design David W. Williams, *Chicago, Illinois*
Fitch RichardsonSmith, *Worthington, Ohio*
Typographic suppliers Harlan Type and in-house
Clients Fitch RichardsonSmith and Exploratory Design Lab
Principal types Baskerville and Frutiger
Dimensions 7½ x 10 in. (19.1 x 25.4 cm)

Newsletter

Typography/Design **Kit Hinrichs and Terri Driscoll,** *San Francisco, California*

Art Director **Kit Hinrichs**

Typographic supplier **EuroType**

Studio **Pentagram Design**

Client **Art Center College of Design**

Principal type **Bodoni Antiqua**

Dimensions **11 x 17 in. (27.9 x 43.2 cm)**

Transmittal Form

Industrial Design A+O Interior Architecture

To

Date
Project
Project No.

The following drawings are being:

Drawings ☐ mailed ☐ delivered ☐ picked up ☐ forwarded under separate cover

Drawing No. Description No. of Copies

Industrial Design A+O Interior Architecture

Industrial Design A+O Interior Architecture

Maureen Seitz

390 Bryant Street
Space 311
San Francisco
CA 94107
415 543 1448

A+O Industrial Design + Interior Architecture

Stationery
Typography/Design Raul Cabra, *San Francisco, California*
Art Director Lucille Tenazas
Typographic suppliers EuroType and Andresen Typographics
Studio Tenazas Design
Client A + O Industrial Design and Interior Architecture
Principal types Univers 55 and Univers 75
Dimensions 8½ x 11 in. (21.6 x 27.9 cm)

Stationery
Typography/Design **Kathleen Forsythe and Julie Steinhilber,**
Cambridge, Massachusetts
Typographic supplier **Wrightson Typographers**
Studio **Forsythe Design**
Client **Forsythe Design**
Principal types **Janson and Bank Script**
Dimensions **8½ x 11 in. (21.6 x 27.9 cm)**

Stationery
Typography/Design **Margo Chase,** *Los Angeles, California*
Typographic supplier **Cliff Typographers**
Studio **Margo Chase Design**
Client **Margo Chase Design**
Principal types **Antikva Margaret Extra Bold, Nuptial Script, and Meridien Bold Italic**
Dimensions **8½ x 11 in. (21.6 x 27.9 cm)**

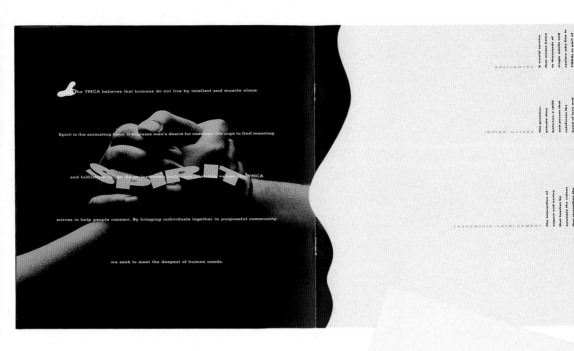

Annual Report
Typography/Design **Pat and Greg Samata**, *Dundee, Illinois*
Typographic supplier **Paul Thompson**
Studio **Samata Associates**
Client **YMCA of Metropolitan Chicago**
Principal types **Futura Extra Bold Expanded and Stymie Extended**
Dimensions **9¾ x 9¾ in. (24.8 x 24.8 cm)**

Stationery
Typography/Design **Tom Kluepfel and Christopher Johnson,** *New York, New York*
Typographic suppliers **Trufont Typographers and in-house**
Studio **Drenttel Doyle Partners**
Client **Equitable Art Advisory**
Principal type **Goudy Old Style**
Dimensions **Various**

On March 23, 1988, Lance and Shawn met for the

first time. It was an event that

would change the course of their lives.

Invitation
Typography/Design **Willie Baronet,**
 Dallas, Texas
Letterers **Willie Baronet and Michael Connors**
Typographic supplier **In-house**
Agency **Knape & Knape**
Client **Shawn and Lance Cantor**
Principal type **ITC Century Light Italic**
Dimensions **3½ x 5 in. (8.9 x 12.7 cm)**

86

Book Cover
Typography/Design **Henry Sene Yee,** *New York, New York*
Typographic supplier **Maxwell Typographers**
Studio **Random House, Inc.**
Client **Schocken Books**
Principal types **Long Tall Good Wood (Beautiful Faces brochure) and Eagle Bold**
Dimensions **5³⁄₁₆ x 8 in. (13.2 x 20.3 cm)**

Packaging
Typography/Design **Charles S. Anderson,** *Minneapolis, Minnesota*
Letterer **Charles S. Anderson**
Typographic supplier **LinoTypographers,** *Fort Worth, Texas*
Studio **The Duffy Design Group**
Client **Phillip Morris**
Principal types **Futura, Eagle Bold (metal), and handlettering**
Dimensions **3½ x 5 in. (8.9 x 12.7 cm)**

Book
Typography/Design **Carin Goldberg,**
New York, New York
Typographic supplier **Photo-Lettering, Inc.**
Studio **Carin Goldberg Design**
Client **Harper and Row**
Principal type **Palisade Graphic**
Dimensions **5⁵⁄₁₆ x 8 in. (13.5 x 20.3 cm)**

Book Cover
Typography/Design **Carin Goldberg,**
New York, New York
Typographic supplier **The Type Shop**
Studio **Carin Goldberg Design**
Client **Simon & Schuster**
Principal type **Washington Bold**
Dimensions **6 x 9¼ in. (15.2 x 23.5 cm)**

Book
Typography/Design **Charles S. Anderson and Dan Olson,** *Minneapolis, Minnesota*
Calligraphers **Charles S. Anderson, Dan Olson, and Randall Dahlk**
Typographic supplier **LinoTypographers,** *Fort Worth, Texas*
Studio **Charles S. Anderson Design Company**
Client **French Paper Company**
Principal types **Spartan Bold (metal) and handlettering**
Dimensions **8½ x 5¹¹⁄₁₆ in. (21.6 x 14.4 cm)**

At Print Craft, even our trademarks are trademarked.™ 612-633-8122

Poster
Typography/Design **Charles S. Anderson and Dan Olson,** *Minneapolis, Minnesota*
Letterer **Randall Dahlk**
Typographic supplier **LinoTypographers,** *Fort Worth, Texas*
Studio **Charles S. Anderson Design Company**
Client **Print Craft, Inc.**
Principal types **Brush (metal) and handlettering**
Dimensions **24½ x 32½ in. (62.2 x 82.6 cm)**

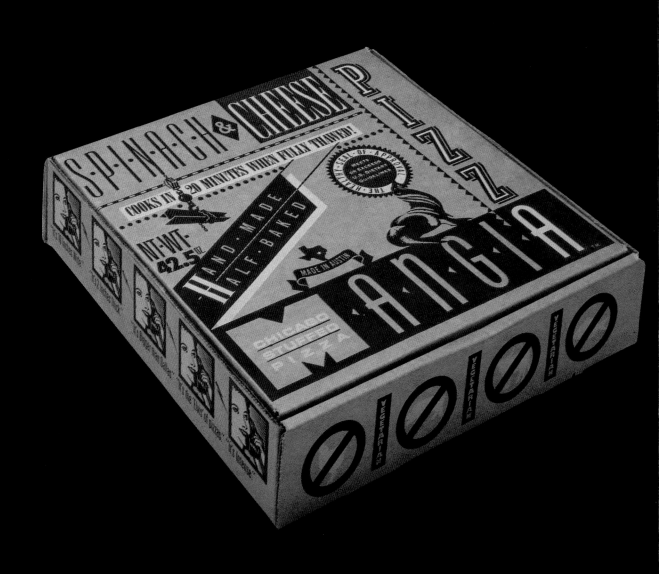

Packaging
Typography/Design **Mike Hicks and Duana Gill,** *Austin, Texas*
Typographic supplier **Pro Type**
Studio **HIXO, Inc.**
Client **Mangia Pizza**
Principal types **Poster Bodoni Compressed and Trade Gothic Extra Condensed**
Dimensions **10½ x 10¾ x 2⅜ in. (26.5 x 27 x 6 cm)**

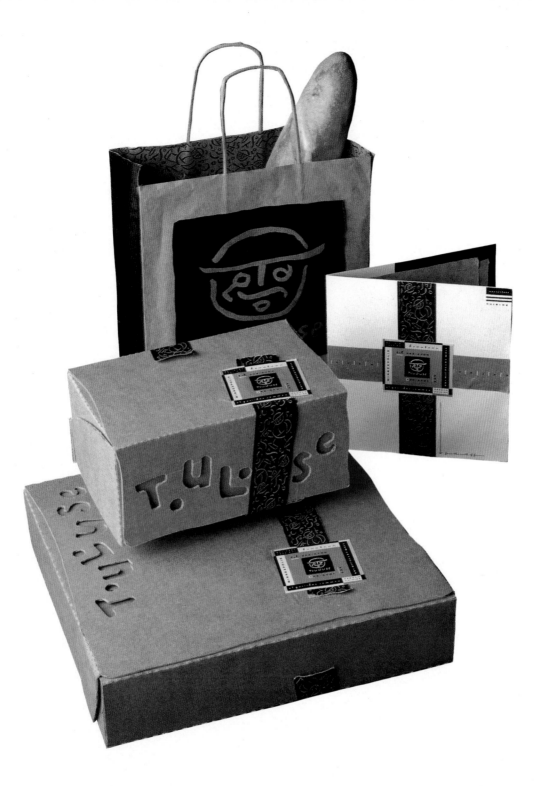

Corporate Identity
Typography/Design **Haley Johnson and Todd Waterbury,**
Minneapolis, Minnesota
Letterer **Todd Waterbury**
Typographic suppliers **Great Faces and P & H Photo Composition**
Studio **The Duffy Design Group**
Client **D'Amico & Partners**
Principal types **Venus Bold Extended, Uranus, and handlettering**
Dimensions **Various**

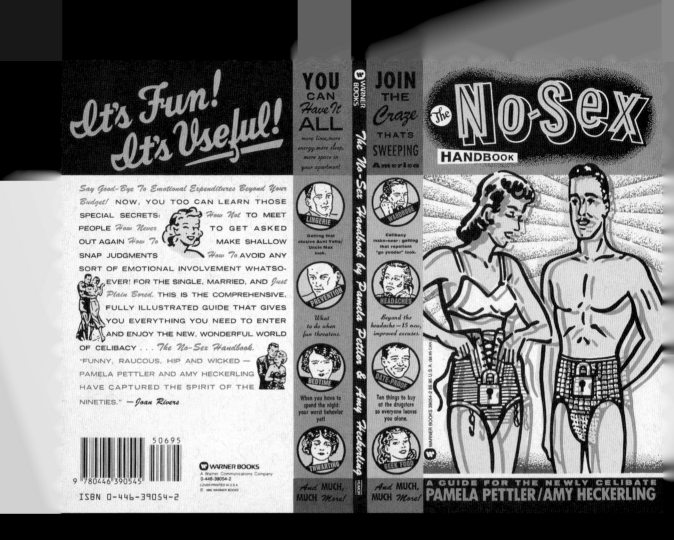

Book

Typography/Design **Charles Spencer Anderson,** *Minneapolis, Minnesota*
Art Director **Jackie Merri Meyer** *New York, New York*
Letterers **Charles Spencer Anderson and Randy Dahlk**
Typographic supplier **LinoTypographers,** *Fort Worth, Texas*
Studio **Charles S. Anderson Design Company**
Client **Warner Books**
Principal types **Various and handlettering**
Dimensions 5¼ x 8 in. (13.3 x 20.3 cm)

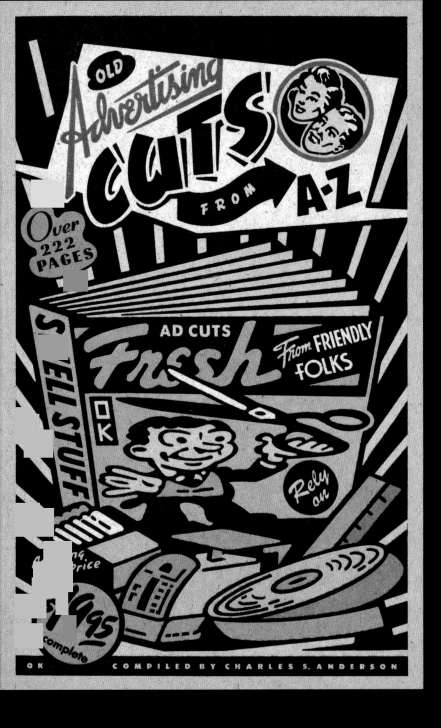

Book
Typography/Design **Charles S. Anderson,**
Minneapolis, Minnesota
Calligraphers **Charles S. Anderson and Lynn Schulte**
Typographic supplier **LinoTypographers,** *Fort Worth, Texas*
Studio **Charles S. Anderson Design Company**
Client **French Paper Company**
Principal types **Futura Bold Condensed, Memphis Bold (metal),
and handlettering**
Dimensions **5½ x 9 in. (14 x 22.9 cm)**

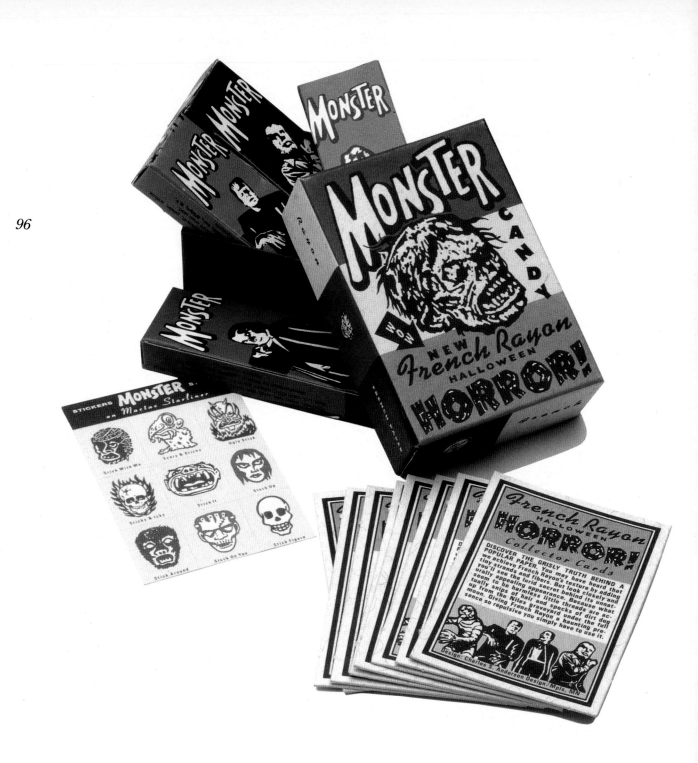

Ad Package
Typography/Design **Charles S. Anderson and Dan Olson,**
Minneapolis, Minnesota
Calligraphers **Charles S. Anderson and Randy Dahlk**
Typographic supplier **LinoTypographers,** *Fort Worth, Texas*
Studio **Charles S. Anderson Design Company**
Client **French Paper Company**
Principal types **Spartan (metal) and handlettering**
Dimensions **2 x 3½ in. (5.1 x 8.9 cm)**

Poster and Postcard
Typography/Design **Charles S. Anderson and Dan Olson,**
Minneapolis, Minnesota
Letterer **Charles S. Anderson**
Typographic supplier **LinoTypographers,** _Fort Worth, Texas_
Studio **Charles S. Anderson Design Company**
Client **Ginza Graphic Gallery**
Principal types **Futura, Personal Computer Japanese Type, and handlettering**
Dimensions **Poster, 28¾ x 40½ in. (73 x 102.9 cm);**

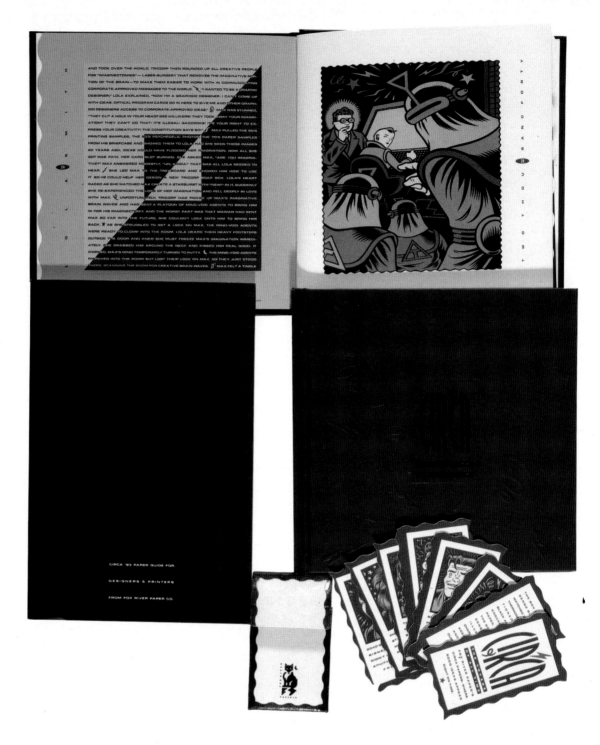

Campaign
Typography/Design **Sharon Werner,**
Minneapolis, Minnesota
Letterer **Lynn Schulte**
Typographic supplier **TypeShooters**
Studio **The Duffy Design Group**
Client **Fox River Paper Company**
Principal types **Eurostyle Extended and handlettering**
Dimensions **Various**

Poster
Typography/Design **Sharon Werner,**
Minneapolis, Minnesota
Letterer **Lynn Schulte**
Typographic supplier **TypeShooters**
Studio **The Duffy Design Group**
Client **Fox River Paper Company**
Principal types **Eurostyle Extended and handlettering**
Dimensions **20 x 36 in. (50.8 x 91.4 cm)**

Poster
Typography/Design Gerald Bustamante,
San Diego, California
Letterer Gerald Bustamante
Typographic supplier Ace Hardware
Studio Studio Bustamante
Client Bicycling West, Inc.
Principal types Helvetica, Gothic, and handlettering
Dimensions 19 x 27 in. (48.3 x 68.6 cm)

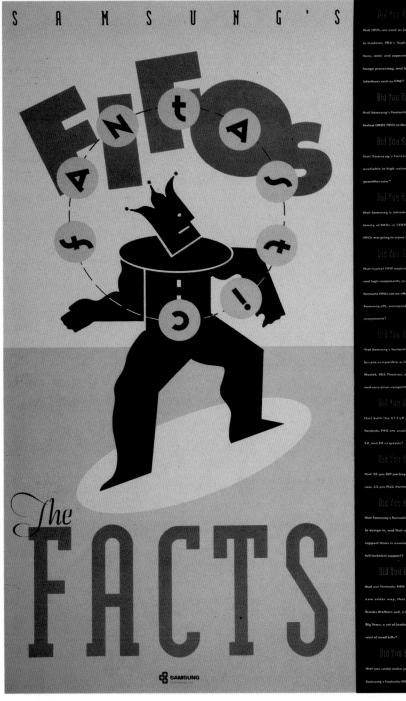

Posters
Typography/Design **Leslie Dressel,**
San Francisco, California
Typographic supplier **In-house**
Agency **Curtin Emerson Ransick Advertising**
Studio **Paul Curtin Design**
Client **Samsung Semiconductor**
Principal types **Futura and Modula Serif Bold**
Dimensions **24 x 38 in. (61 x 96.5 cm)**

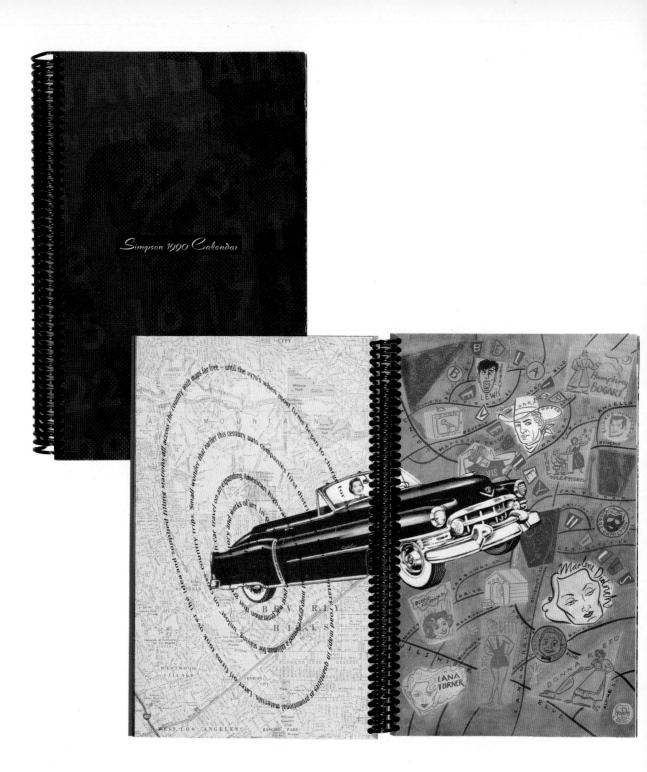

Desk Calendar
Typography/Design **Steven Tolleson and Renee Sullivan,**
San Francisco, California
Typographic suppliers **Spartan Typographers and EuroType**
Studio **Tolleson Design**
Client **Simpson Paper Company**
Principal type **Garamond Berthold**
Dimensions **6 x 9 in. (15.5 x 22.9 cm)**

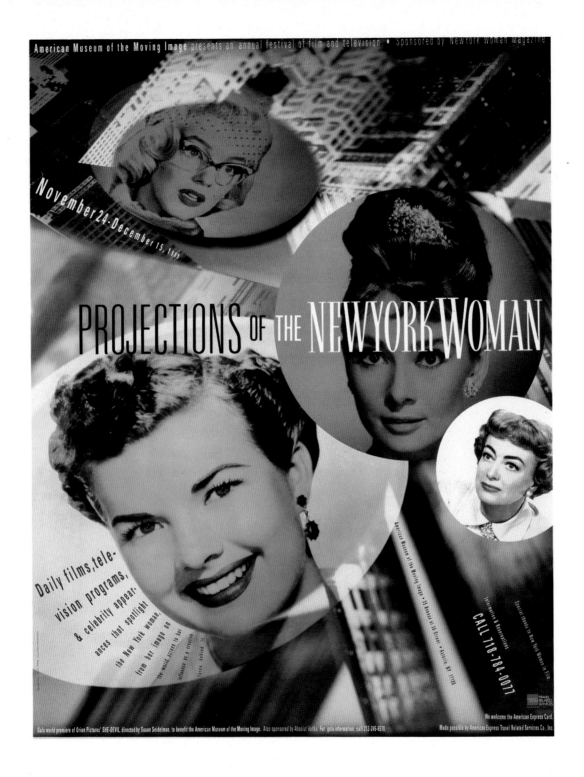

Poster
Typography/Design **David Sterling and Jane Kosstrin,**
 New York, New York
Typographic supplier **In-house**
Studio **Doublespace**
Client **American Museum of the Moving Image**
Principal type **Univers**
Dimensions **36 x 48 in. (91.4 x 121.9 cm)**

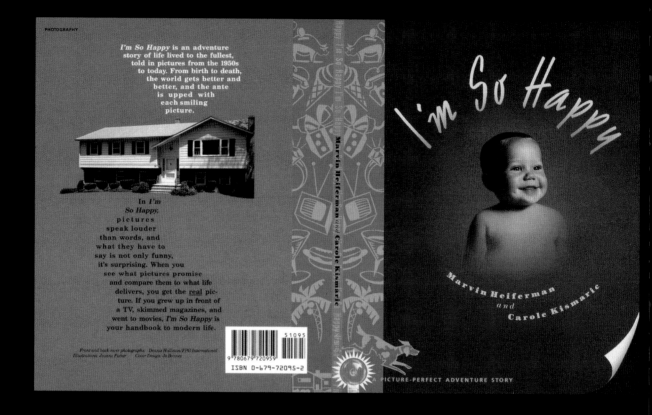

Book
Typography/Design **Jo Bonney,** *New York, New York*
Art Director **Susan Mitchell**
Letterer **Jo Bonney**
Typographic supplier **Typographic Images, Inc.**
Studio **Jo Bonney**
Client **Vintage Books**
Principal types **ITC Century Ultra, Century Schoolbook, and handlettering**
Dimensions **9¼ x 15 in. (23.5 x 38.1 cm)**

T R U M P

THE SHOT HEARD 'ROUND THE WORLD

DONALD Trump, by the time of his 50th birthday, had become the world's most notorious recluse. He lived alone with his third wife, Cornelia Guest Trump in the Trump Triplex atop Trump Tower and it was said that they hadn't had a visitor in more than three years. Word had it that Trump's wispy, shoulder-length blond hair had grayed and become brittle; that his fingernails, which he refused to cut, had become gnarled and hideously twisted. It was said that he stored his urine in 10-liter mason jars which he then stowed away in vast underground vaults beneath Trump Tower.

IN HIS feral, delusionary madness the trillionaire seized upon the idea of upstaging the end-of-the-millennium celebrations in Cairo, by dismantling one of the pyramids, shipping it across the ocean and reassembling it in Central Park. An army of engineers and more than twenty thousand men were flown to Egypt to dismantle the great pyramid stone by stone. One hundred oil tankers brought it to New York

Harbor. For months, 42nd Street was unusable as legions of flatbed trucks ferried the pyramid to the park.

WOULD anyone who attended the celebrations ever forget them—especially their horrifying conclusion? There, against the backdrop of the towers along Central Park West, and covering most of the Great Lawn, loomed the haunting figure of the pyramid. Every Scots pipe band that could be hired was flown across the Atlantic. The food, which was laid out on 100-yard banquet tables, was sufficient, it was estimated, to feed the Sudan for a dozen years.

IF EVER there was a center of the earth and of all eternity, this surely was it. When the crowd began a ten-minute countdown to the millennium's end, armed members of the Trump Guard turned 10,000-kilowatt searchlights on the heavens. (Soviet cosmonauts stationed on the Moon claimed later to have seen the glow.) At the stroke of one minute to midnight, there was a deafening hush as Trump, through massive loudspeakers he had installed in the Triplex—and relayed around the world via Trump Satellite hookup—ordered the whole city to endure a minute of silence. Then, one second before midnight, the jittery cool night air was ripped by the amplified sound of a single gunshot. As the report sped 'round the planet, every head in the park turned to where the shot came from—the Triplex atop Trump Tower! The century, the millennium and the Age of Trump, were over.

Book
Typography/Design **Paula Scher**, *New York, New York*
Typographic suppliers **Koppel & Scher, Inc., and Protype, Inc.**
Studio **Koppel & Scher, Inc.**
Client **Avon Books, Inc.**
Principal types **Garamond No. 3 and various wood faces**
Dimensions **8⅛ x 10¾ in. (20.6 x 27.3 cm)**

Direct Mail Piece
Typography/Design Brent Croxton and Steve Guarnaccia,
San Francisco, California
Letterer Steve Guarnaccia
Typographic supplier Andresen Typographics
Agency Altman & Manley
Client Physicians Health Services
Principal types Copperplate Heavy and handlettering
Dimensions 7 x 7 in. (17.8 x 17.8 cm)

A GUIDE TO SCI-FI

EARTHLINGS, TAKE HEED: INALIENABLE DELIGHTS HAVE BEAMED DOWN FROM THE SILVER SCREEN INTO YOUR VCR

BY
PETER BISKIND

THE STUFF THAT PASSES FOR SCI-FI THESE DAYS—the teen space epics, the cutesy, feel-good, inspirational fantasies, the endless drecky Trekkie junk—isn't worth the celluloid it's shot on. Real sci-fi, the genuine article, the pods and blobs, big bugs, little green men, 50-foot women, and fantastic voyagers, was spawned in the '50s, when, for reasons best known to students of popular culture (the Bomb's as good an explanation as any), the genre finally came into its own. By the decade's end, sci-fi had virtually disappeared, only to reemerge in the late '60s in more bizarre and ambitious, if less interesting, forms: *Barbarella*, Jane Fonda's exercise in kitsch; *2001: A Space Odyssey*, Stanley Kubrick's psychedelic pudding; the campy *Planet of the Apes* cycle; and John Boorman's mannered *Zardoz*. Then in 1977 came *Star Wars*, and the rest, as they say, is history. The following selection is weighted toward the '50s, sci-fi's golden age, a time when real monsters didn't eat quiche.

THE THING (1951). James Arness played the bloodthirsty "carrot" that slurps up the boys at the base in this pioneering flying-saucer thriller, which scared the pants off '50s audiences. *The Thing*, following quickly on the heels of *Destination Moon* and *Rocketship X-M*, was one of the first '50s sci-fi movies to feature a nasty monster from outer space. In the early drafts of the zingy script (by Charles Lederer), the visitor was to have been considerably more *outré*, but apparently the special effects folks weren't up to the job, and it turned out to be nothing more unusual than an oversized human. Given the primitive nature of the effects, it's a testimony to the skill of producer Howard Hawks and director Christian Nyby that the film holds up as well as it does. (Sci-fi does not live by effects alone—witness the fate of the dumb 1982 remake, by John Carpenter.) When they're not busy devising ways of getting rid of the alien, the soldiers and scientists fight over who's going to run the show—the movie's real theme. The no-

nonsense soldiers are led by Kenneth Tobey (whose role here ensured him endless cameos from hostage-mad movie-brat directors of the future), while the scientists are led by a soft-on-aliens Thing-symp egghead (Robert Cornthwaite). Needless to say, the film's allegiances are clear. Don't miss the classic paranoid injunction—"Watch the skies!"—at the end. Turner Home Entertainment, $19.98.

THE DAY THE EARTH STOOD STILL (1951). "Klaatu barada nikto" are the unforgettable (at least to trivia pursuers) words Patricia Neal uses to discourage the robot Gort (played by Lock Martin, doorman at Grauman's Chinese Theater and one of the tallest men in Hollywood) from incinerating Washington, D.C., with its laser eye. Robert Wise's thinly disguised attack on the arms race, with Michael Rennie as Klaatu, the emissary from outer space who warns quarreling humans to shape up or ship out, proves that messages don't have to be sent by Western Union. The film has a you-are-there documentary flavor that makes it surprisingly convincing and goes a long way toward normalizing some of the loonier aspects of the script (such as Klaatu's Christ-like return from the dead). Klaatu's stylish flying saucer served as a prototype for spaceships to come, particularly Steven Spielberg's dolled-up, rhinestone version in *Close Encounters of the Third Kind*. Look for vintage howlers: Walter Reed Army Medical Center doctors smoking, and '50s newscasters Gabriel Heater, H. V. Kaltenborn, Drew Pearson, and Elmer Davis casting with their hats on. CBS/Fox Video, $19.98.

THE WAR OF THE WORLDS (1953). A suspiciously shaped meteor sets Geiger counters aflutter when it lands in California. Unlike the soldier in *The Day the Earth Stood Still*, who shoots Klaatu the moment he sets foot on terra firma, the locals in this film are friendly, only to be vaporized by ill-intentioned Martians who want Earth for themselves. Miraculously, the special effects in producer George Pal's harrowing classic of interplanetary carnage,

Magazine Spread

Typography/Design Robert Best, David Walters, and Mary Ann Salvato,
New York, New York

Letterer Ann Pomeroy
Typographic supplier In-house
Client Premiere Magazine
Principal type Bembo

PART ONE: THE SHIFT Most of us have lived our entire lives with the threat of the cold war, the terror of nuclear annihilation. But now, for the first time in memory, peace–not war–is breaking out around the world. From Moscow to Washington, the old assumptions are falling away, and a new and vastly different era is coming into being. After all the darkness and carnage of the twentieth century, is man finally ready to give up his most catastrophic habit– the urge to make war? BY LAWRENCE WRIGHT

PEACE

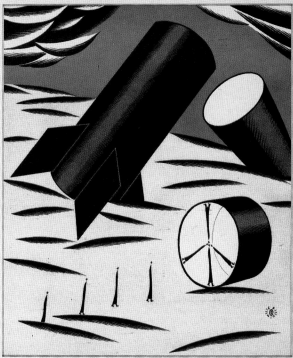

BY T. CORAGHESSAN BOYLE

THE FOLLOWING EXCERPT IS FROM T. CORAGHESSAN BOYLE'S FORTHCOMING NOVEL
'EAST IS EAST,' WHICH WILL BE PUBLISHED IN 1990. BOYLE IS THE AUTHOR OF 'WORLD'S
END,' 'IF THE RIVER WAS WHISKEY' AND OTHER FICTION. IN THIS PASSAGE, NEAR THE
BEGINNING OF 'EAST IS EAST,' A COUPLE LOUNGING ON A BOAT OFF THE COAST OF
GEORGIA ARE SURPRISED BY A VISITOR, WHO EMERGES FROM THE SEA.

"Shouldn't we have a light or something?"

"Hm?" His voice was a warm murmur at her throat. He was half-asleep.

"Running lights," Ruth said, her own voice pitched low, almost a whisper, " – isn't that what they call them?"

The boat rocked softly on the swells, serene and stable, rocked like a cradle, like the big lumpy bed with the Magic Fingers massage in the motel they'd stumbled across her first night in Georgia. There was a breeze too, salt and sweet at the same time, gentle, but just strong enough to keep the mosquitoes at bay. The only sound was of the water caressing the hull, soothing, rhythmic, a run and trickle that played in her head with the strains of a folk song she'd forgotten ten years ago. The stars were alive and conscious. The champagne was cold. He didn't answer.

Ruth Dershowitz was lying naked in the bow of Saxby Lights's eighteen-foot runabout. (Actually, the boat belonged to his mother, as did everything else in and attached to the big house on Tupelo Island.) Saxby was stretched out beside her, the drowsy flat of his cheek pressed to the swell of her breast. Each time the boat dipped beneath her, the friction of his fashionable stubble sent small fires burning all the way down to her toes. Five minutes earlier Saxby had knelt before her, adjusted her hips on the broad flat plank of the seat, stroked open her thighs and moved himself into her. Ten minutes before that she'd watched him grow hard in the dimming light as he sat across from her and tried, unsuccessfully, to inflate a plastic air mattress to cushion them. She'd watched him, bemused and excited, until finally she'd whispered, "Forget it, Sax – just come over here." Now he was asleep.

For a while she listened to the water and thought nothing. And then the image of Jane Shine, her enemy, rose up before her, and she banished it with a vision of her own inevitable triumph, her own inchoate stories jelling into art, conquering magazines and astonishing the world, and then she was thinking about the big house, thinking about her fellow writers, the sculptors and painters and the single walleyed composer whose music sounded like slow death in the metronome factory. She'd been among them for a week now, one week of an indefinite stay – a succession of months that came alive in her mind, months with little gremlin faces and hunched shoulders, leapfrogging into the glorious, limitless, sunlit and rent-free future. No more waitressing, no more hack work, no more restaurant reviews, *Parade* banalities or *Cosmo*

ILLUSTRATION BY TOM CURRY

Magazine Spread

Typography/Design **Debra Bishop,**
New York, New York

Typographic supplier **In-house**

Studio **Rolling Stone**

Client **Rolling Stone**

Principal **type Will Bold Open**

Dimensions **12 x 20 in. (30.5 x 50.8 cm)**

Book Cover

Typography/Design **Susan Hochbaum and Peter Harrison,**
New York, New York
Illustrator **Jean Tuttle**
Studio **Pentagram Design**
Client **Dell Publishing**
Principal type **Handlettering**
Dimensions 9¼ × 19¾ in. (24.1 × 7.6 cm)

Poster
Typography/Design **Tatsuomi Majima**, *Tokyo, Japan*
Letterer **Tatsuomi Majima**
Typographic supplier **Majima Design Inc.**
Agency **Gulliver Book**
Studio **Majima Design Inc.**
Client **Gulliver Co., Ltd.**
Principal types **Various and handlettering**
Dimensions 28¾ x 40½ in. (73 x 102.9 cm)

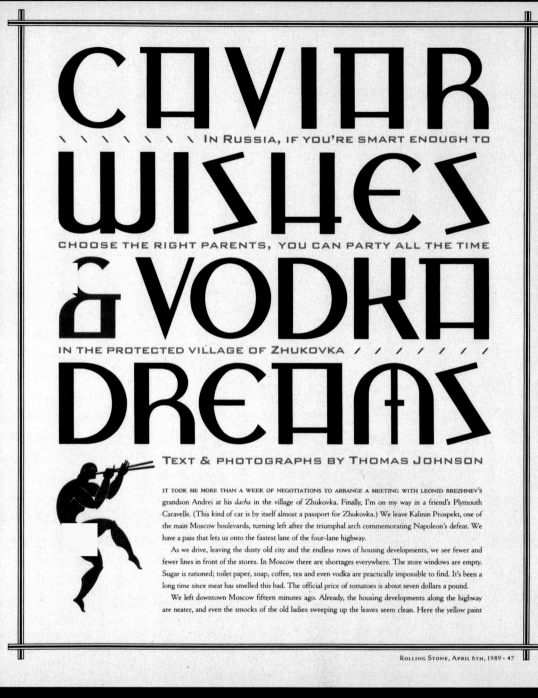

CAVIAR

\ \ \ \ \ \ \ \ \ In Russia, if you're smart enough to

WISHES

CHOOSE THE RIGHT PARENTS, YOU CAN PARTY ALL THE TIME

&VODKA

IN THE PROTECTED VILLAGE OF ZHUKOVKA / / / / / / /

DREAMS

TEXT & PHOTOGRAPHS BY THOMAS JOHNSON

IT TOOK ME MORE THAN A WEEK OF NEGOTIATIONS TO ARRANGE A MEETING WITH LEONID BREZHNEV'S grandson Andrei at his *dacha* in the village of Zhukovka. Finally, I'm on my way in a friend's Plymouth Caravelle. (This kind of car is by itself almost a passport for Zhukovka.) We leave Kalinin Prospekt, one of the main Moscow boulevards, turning left after the triumphal arch commemorating Napoleon's defeat. We have a pass that lets us onto the fastest lane of the four-lane highway.

As we drive, leaving the dusty old city and the endless rows of housing developments, we see fewer and fewer lines in front of the stores. In Moscow there are shortages everywhere. The store windows are empty. Sugar is rationed; toilet paper, soap, coffee, tea and even vodka are practically impossible to find. It's been a long time since meat has smelled this bad. The official price of tomatoes is about seven dollars a pound.

We left downtown Moscow fifteen minutes ago. Already, the housing developments along the highway are neater, and even the smocks of the old ladies sweeping up the leaves seem clean. Here the yellow paint

Magazine Page
Typography/Design **Gail Anderson,**
New York, New York
Letterer **Dennis Ortiz-Lopez**
Typographic supplier **In-house**
Studio **Rolling Stone**
Client **Rolling Stone**
Principal type **Handlettering**
Dimensions **10 x 12 in. (24.8 x 30.5 cm)**

Magazine
Typography/Design **MIHO,** *Pasadena, California*
Letterer **MIHO**
Typographic suppliers **CCI Typographers and United States Information Agency**
Client **United States Information Agency**
Principal types **Times Roman and Helvetica**
Dimensions **8½ x 11 in. (21.6 x 27.9 cm)**

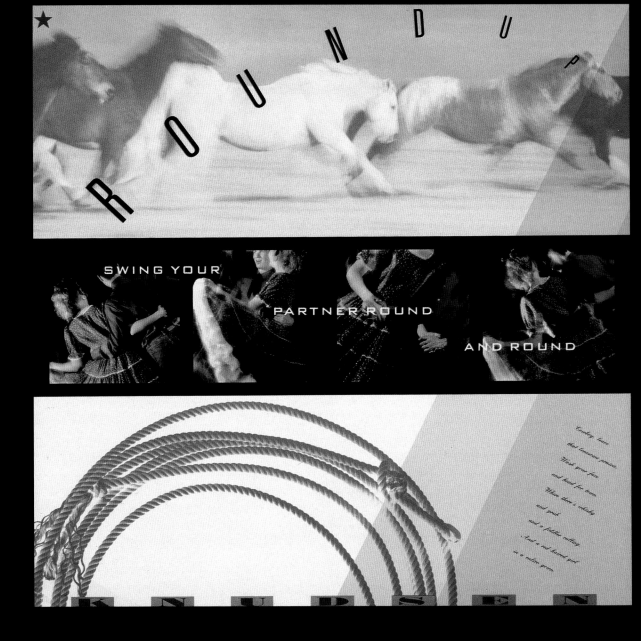

Poster
Typography/Design **Lynn Dougherty,** *Denver, Colorado*
Typographic supplier **Typographic Arts**
Studio **Beauchamp Group, Inc.**
Client **Knudsen Printing**
Principal type **Univers 49 Ultra Condensed**
Dimensions **17½ x 17½ in. (44.5 x 44.5 cm)**

Invitation
Typography/Design **Louis M. Goldberg and Elizabeth J. Murphy,**
Chicago, Illinois
Typographic supplier **RyderTypes**
Studio **Primary Communications**
Client **The Atchison, Topeka and Santa Fe Railway Company**
Principal type **Palatino Italic**
Dimensions **24½ x 4½ in. (62.2 x 11.4 cm)**

Greeting Card
Typography/Design **Takaaki Matsumoto,** *New York, New York*
Art Directors **Takaaki Matsumoto and Michael McGinn**
Letterer **Takaaki Matsumoto**
Typographic supplier **JCH Group Ltd.**
Agency **M Plus M Incorporated**
Client **M Plus M Incorporated**
Principal type **Copperplate Gothic**
Dimensions **10⁵⁄₁₆ x 4⁵⁄₈ in. (27.8 x 11.7 cm)**

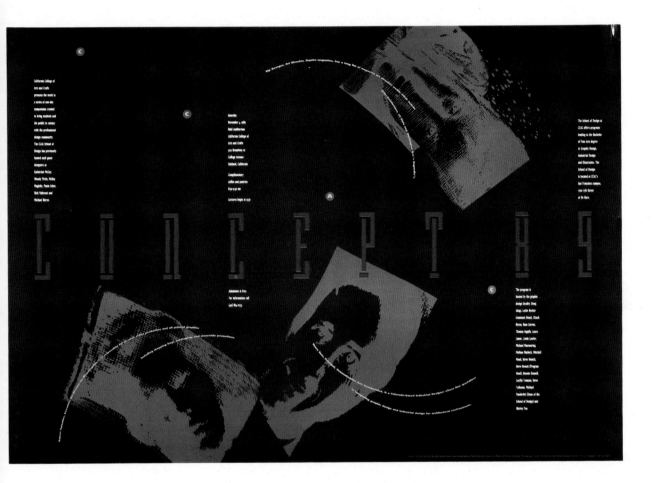

Poster
Typography/Design **Ross Carron,** *San Francisco, California*
Typographic supplier **In-house**
Studio **Ross Carron Design**
Client **California College of Arts and Crafts**
Principal types **Matrix Condensed and Futura Extra Bold**
Dimensions **17 x 23 in. (43.2 x 58.4 cm)**

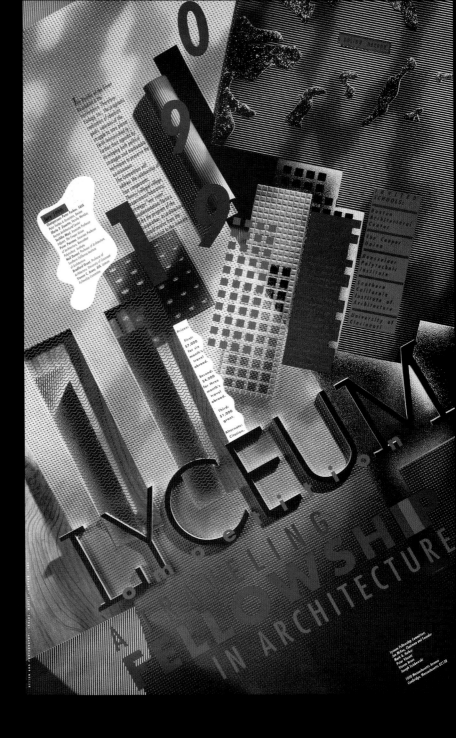

Poster
Typography/Design **Nancy Skolos,**
Boston, Massachusetts
Typographic suppliers **Protype and in-house**
Studio **Skolos Wedell + Raynor**
Client **Lyceum Fellowship Committee**
Principal type **Futura**
Dimensions **20 x 32 in. (50.8 x 81.3 cm)**

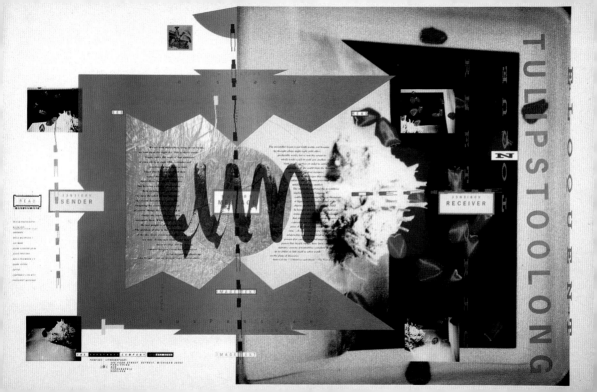

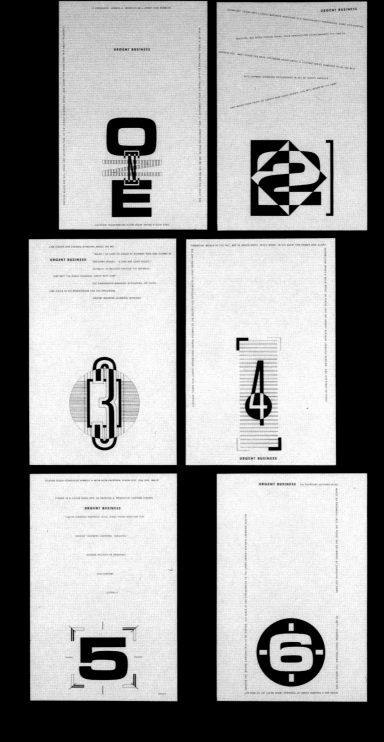

Series
Typography/Design **Barsuhn Design,** *Minneapolis, Minnesota*
Letterer **Sandra E. Harper**
Typographic suppliers **deRuyter-Nelson Publications, Inc., and Letterworx, Inc.**
Studio **Barsuhn Design**
Client **NWNL Management Corporation**
Principal types **Avant Garde Book and Bold and handlettering**
Dimensions **5¼ x 7¹⁵⁄₁₆ in. (13.3 x 20.1 cm)**

AIGA

In one ear out the other!

Announcement
Typography/Design **Steven Tolleson,**
 San Francisco, California
Typographic supplier **Andresen Typographics**
Studio **Tolleson Design**
Client **AIGA San Francisco**
Principal type **ITC Newtext**
Dimensions **5⅝ x 8½ in. (14.3 x 21.6 cm)**

BabY

DEREK

DAVIS

KAMPA

Marcellina and David Kampa are proud to announce the birth of their very first child —a beautiful baby boy named Derek Davis.

The duo is now a trio.

- TUESDAY
- JULY 13TH 1989
- 5:04 P.M.
- 7 POUNDS
- 12½ OUNCES
- 20½ INCHES

Logotype
Typography/Design **Scott Johnson,**
Rockford, Illiniois
Typographic supplier **Typeworks**
Studio **Larson Design Associates**
Client **Dave and Linda Norberg**
Principal type **Avant Garde Bold (modified)**

Catalog
Typography/Design **Barsuhn Design,** *Minneapolis, Minnesota*
Letterer **Scott Barsuhn**
Typographic supplier **P & H Photo Composition, Inc.**
Studio **Barsuhn Design**
Client **Minneapolis College of Art and Design**
Principal types **Century Book, Radiant Extra Bold Condensed, and Helvetica Regular**
Dimensions **16 x 12 in. (30.5 x 40.6 cm)**

Promotion
Typography/Design **Lisa Ashworth and Joel Fuller,** *Miami, Florida*
Letterer **Sidney Richards**
Typographic suppliers **Graphic Composing Systems and personal collection of Sidney Richards**
Studio **Pinkhaus Design Corporation**
Client **Chuck Mason**
Principal type **Binder Style Heavy**
Dimensions **11 x 14 in. (27.9 x 35.6 cm)**

Stationery
Typography/Design Steven Tolleson and Nancy Paynter,
San Francisco, California
Typographic supplier Spartan Typographers
Studio Tolleson Design
Client Spartan Typographers
Principal type Garamond Italic
Dimensions 8½ x 11 in. (21.6 x 27.9 cm)

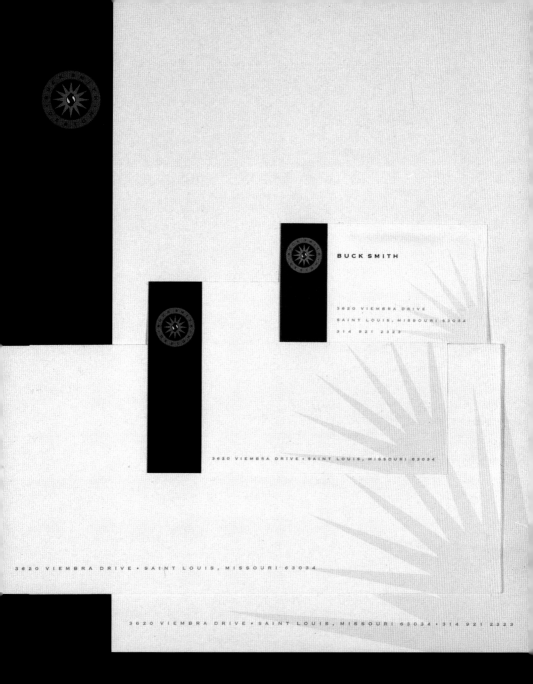

BUCK SMITH

3620 VIEMBRA DRIVE
SAINT LOUIS, MISSOURI 63034
314 921 2323

3620 VIEMBRA DRIVE • SAINT LOUIS, MISSOURI 63034

3620 VIEMBRA DRIVE • SAINT LOUIS, MISSOURI 63034

3620 VIEMBRA DRIVE • SAINT LOUIS, MISSOURI 63034 • 314 921 2323

Stationery
Typography/Design **Buck Smith,** *St. Louis, Missouri*
Typographic suppliers **Composing Room and Diane Kramer**
Studio **Buck Smith Design**
Client **Buck Smith Design**
Principal type **Copperplate Gothic**
Dimensions 8½ x 11 in. (21.6 x 27.9 cm)

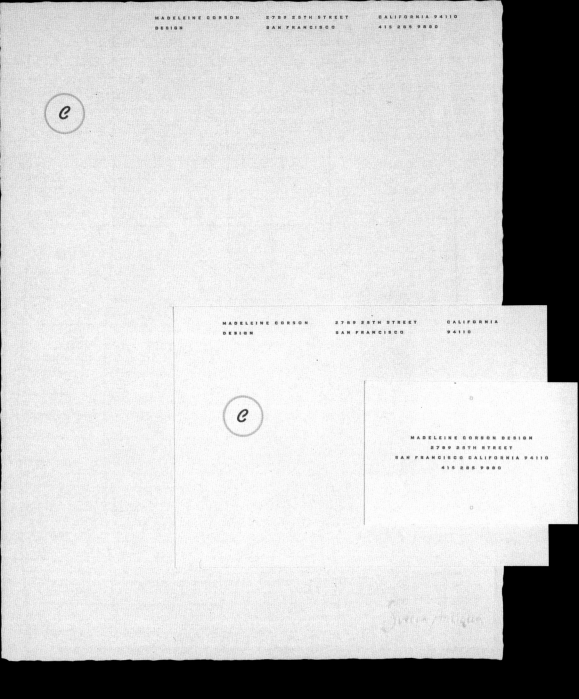

Stationery
Typography/Design **Madeleine Corson,**
San Francisco, California
Typographic supplier **M & H Type**
Studio **Madeleine Corson Design**
Client **Madeleine Corson Design**
Principal type **Stationers Gothic**
Dimensions **8½ x 11 in. (21.6 x 27.9 cm)**

C O V E S T

COVEST FINANCIAL GROUP, INC.

1850 TWO LINCOLN CENTRE, 5420 LBJ FREEWAY

DALLAS, TEXAS 75240

Letterhead
Typography/Design Alan Colvin and Joe Rattan,
Dallas, Texas
Letterer Alan Colvin
Typographic supplier Robert J. Hilton Company, Inc.
Studio Colvin Rattan Design
Client Covest Financial Group, Inc.
Principal type Times Roman
Dimensions 8½ x 11 in. (21.6 x 27.9 cm)

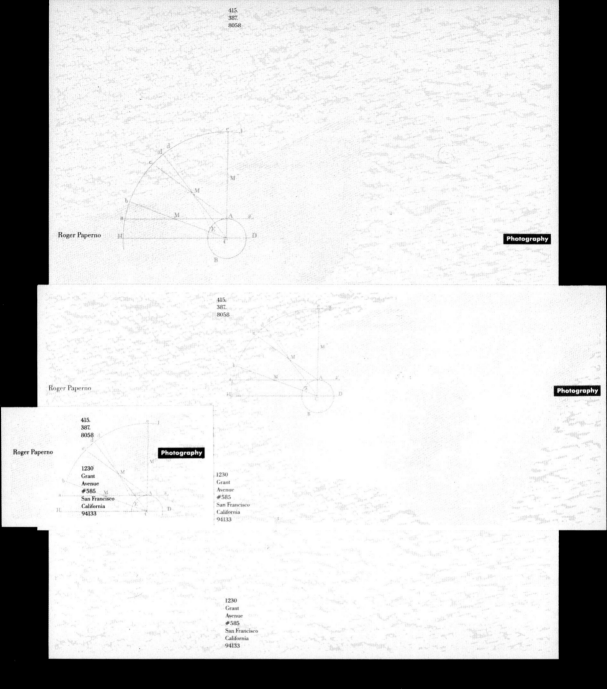

Stationery
Typography/Design **Lisa Levin,** *San Francisco, California*
Typographic supplier **Andresen Typographics**
Studio **Lisa Levin Design**
Client **Roger Paperno Photography**
Principal type **Bodoni**
Dimensions 8½ x 11 in. (21.6 x 27.9 cm)

Stationery
Typography/Design **Michael Vanderbyl,**
San Francisco, California
Typographic supplier **Hester Typography**
Studio **Michael Vanderbyl Design**
Client **Celestial Films**
Principal type **Gill Sans**
Dimensions **8½ x 11 in. (21.6 x 27.9 cm)**

JAWS *The Space Shuttle* PUMP TOOTHPASTE *Star Wars* LYME DISEASE

BERNHARDT FUDYMA

Brochure
Typography/Design Bernhardt Fudyma Design Group,
New York, New York
Typographic supplier In-house
Agency Bernhardt Fudyma Design Group
Client Bernhardt Fudyma Design Group
Principal types Modula and ITC New Baskerville Italic
Dimensions 5⅞ x 5⅞ in. (14.9 x 14.9 cm)

Poster
Typography/Design **Jonathan Skousen and McRay Magleby,**
Provo, Utah
Typographic supplier **In-house**
Studio **BYU Graphics**
Client **Brigham Young University**
Principal types **Granjon and Caslon Open Face**
Dimensions **23 x 35 in. (58.4 x 88.9 cm)**

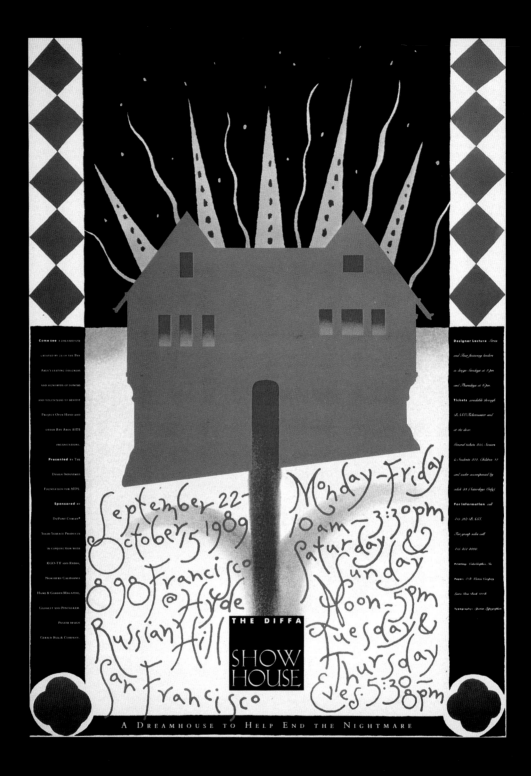

Poster
Typography/Design **Gerald Reis,** *San Francisco, California*
Letterer **Gerald Reis**
Typographic supplier **Spartan Typographers**
Studio **Gerald Reis & Company**
Client **Design Industries Foundation for AIDS (DIFFA)**
Principal types **Bembo, Snell Roundhand, and handlettering**
Dimensions **22 x 32 in. (55.9 x 81.3 cm)**

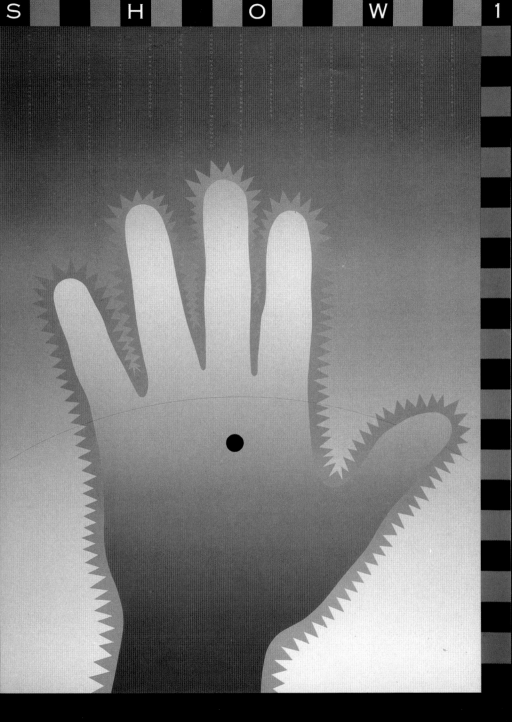

Poster
Typography/Design **Michael Vanderbyl,**
San Francisco, California
Typographic supplier **Andresen Typographics**
Studio **Michael Vanderbyl Design**
Client **California College of Arts and Crafts**
Principal type **Copperplate Gothic**
Dimensions **32½ x 24 in. (82.6 x 61 cm)**

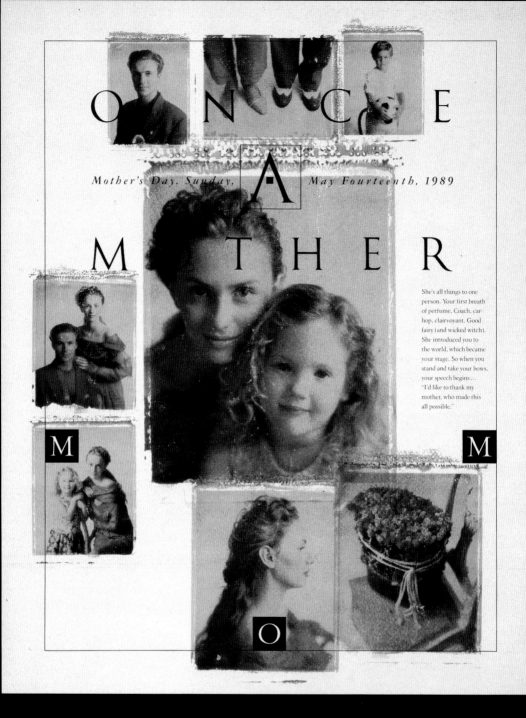

ONCE A MOTHER

Mother's Day, Sunday, May Fourteenth, 1989

She's all things to one person. Your first breath of perfume. Coach, carhop, clairvoyant. Good fairy (and wicked witch). She introduced you to the world, which became your stage. So when you stand and take your bows, your speech begins… "I'd like to thank my mother, who made this all possible."

MMOM

Poster
Typography/Design **Robert Valentine,**
 New York, New York
Agency Bloomingdale's Special Projects
Client Bloomingdale's
Principal type Roman Capital
Dimensions 21 x 27 in. (53.3 x 68.8 cm)

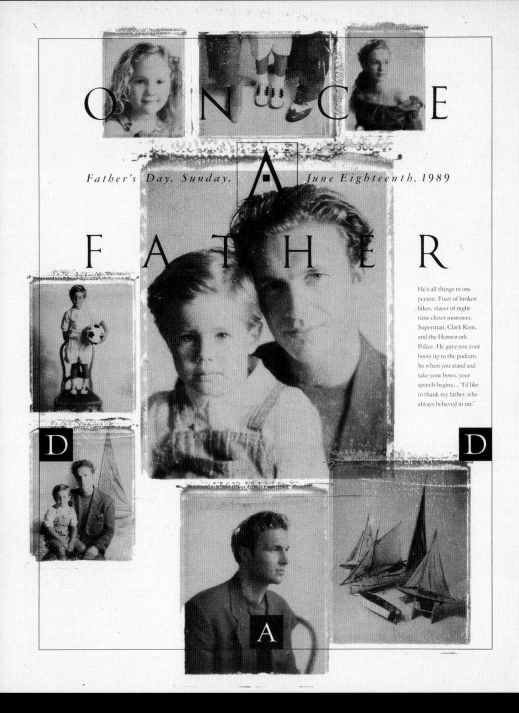

ONCE

Father's Day, Sunday, June Eighteenth, 1989

A

FATHER

He's all things to one
person. Fixer of broken
bikes, slayer of night-
time closet monsters.
Superman, Clark Kent,
and the Homework
Police. He gave you your
boost up to the podium.
So when you stand and
take your bows, your
speech begins…"I'd like
to thank my father, who
always believed in me."

D D

A

Poster
Typography/Design Robert Valentine,
New York, New York
Agency Bloomingdale's Special Projects
Client Bloomingdale's
Principal type Roman Capital
Dimensions 21 x 27 in. (53.3 x 68.6 cm)

Stationery
Typography/Design Sharon Werner,
Minneapolis, Minnesota
Letterer Lynn Schulte
Typographic supplier TypeShooters
Studio The Duffy Design Group
Client Fox River Paper Company
Principal types Eurostyle Extended and handlettering
Dimensions 8½ x 11 in. (21.6 x 27.9 cm)

THE GOAL: NEW LEVELS OF EXCELLENCE

The affinity Curtis Hadland has with creatures of the wild appears in the special blend of biology, mythology, psychology, and sociology that made the "Wolves and Humans" exhibit so appealing to millions of visitors. "Bears: Imagination and Reality" holds equal promise.

t has been over a decade since the 1977 capital campaign for the Science Museum, and the time has come to look toward the future once again.

What will the future hold? The museum intends to maintain and advance the quality programs that have garnered national recognition and spurred countless Minnesota students to a new appreciation of science. These programs include participatory exhibits coupled with science theater and live demonstrations, production of national traveling exhibits and OMNIMAX films, and an active research and collections program.

Next, the museum is crafting an exciting new style for permanent core exhibits, a major vehicle for bringing modern science to an increasingly large and diverse audience. With the help of teachers and educators, the museum is working to revise and expand core exhibits to deliver a new level of meaning and value to students, teachers, and families in the Twin Cities and throughout the state.

Accessibility is another key theme. We plan to expand the museum's education program in order to attract more youngsters toward science-oriented careers. And we have designed ways to make the museum more accessible to low-income families, minorities, girls, and "hard-to-reach" youth, as well as to schools that cannot afford outreach programs.

The Science Museum's growth must be underpinned by financial stability. Protecting our precious legacy is a major thrust for the future. The Campaign for the Science Museum of Minnesota was launched to address these programs and needs.

"In some cultures, the bear is seen as brother or god, in others as menace or nuisance. In developing an exhibit like "Bears: Imagination and Reality," we aim to challenge visitors' assumptions and values. The exhibit addresses biological development, historical and popular images, and human impact on bears' circumstances. • Three-dimensional objects have intrinsic value, but they are also symbols that tell a story. When they are combined with re-created environments, video and audio displays, interactive elements, live demonstrations, theater, and educational packages, the story is a powerful one indeed."

Curtis Hadland
Curatorial Associate
Wildlife Science

River clams. The St. Croix Field Research Center has been established to study the plants, animals, and general ecology of aquatic systems and habitats of the St. Croix River drainage basin.

Northwest Coast Indian bear rattle, part of the 1990 "Bears" exhibit. The exhibit compares the world of the real bear (black and grizzly) with the bear of our imagination.

Book

Typography/Design Leslee Avchen and Laurie Jacobi,
Minneapolis, Minnesota
Typographic supplier Science Museum of Minnesota
Studio Avchen & Jacobi, Inc.
Client The Science Museum of Minnesota
Principal type ITC Stone
Dimensions 8½ x 11¾ in. (21.6 x 29.8 cm)

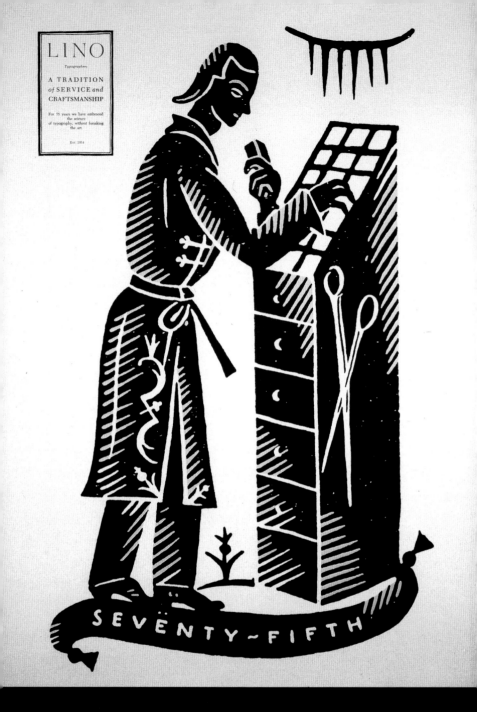

Poster
Typography/Design **Charles S. Anderson and Dan Olson,** *Minneapolis, Minnesota*
Typographic supplier **LinoTypographers,** *Fort Worth, Texas*
Studio **Charles S. Anderson Design Company**
Client **LinoTypographers**
Principal type **Caledonia (metal)**
Dimensions 40½ x 58 in. (102.9 x 147.3 cm)

Poster
Typography/Design **Haley Johnson,**
Minneapolis, Minnesota
Letterer **Haley Johnson**
Typographic supplier **TypeShooters**
Studio **The Duffy Design Group**
Client **Plymouth Music Series**
Principal types **Weidemann and handlettering**
Dimensions **26 x 15 in. (66 x 38.1 cm)**

Poster
Typography/Design **Minoru Niijima,**
 Tokyo, Japan
Typographic supplier **Emiko Izumi**
Studio **Minoru Niijima Design Studio**
Client **Kanazawa Sculpture Exhibition Committee**
Principal type **Univers**
Dimensions **36 x 23½ in. (91.4 x 59.7 cm)**

35.TH
TYPE DIRECTORS SHOW
OF NEW YORK

Ich komme zur Europa-Premiere am

Dienstag, 26. September 1989, um 18 Uhr.

Ich komme in Begleitung mit : . . . Personen.

Ich/wir werden die Ausstellung am

27. September 1989,

28. September 1989 besichtigen.

Ich/wir können leider nicht teilnehmen
und bitte/n um Information über:

Linotype-Schriften

Linotype-Satzsysteme

LinoType Collection

Unterschrift (Absender bitte auf der Rückseite angeben)

Promotion
Typography/Design Olaf Leu,
Frankfurt am Main, West Germany
Letterer Fotosatz Hoffman/Mabo Druck
Typographic supplier Jochen Dietz c.o. Linotype AG
Studio Olaf Leu + Partner
Client Linotype AG
Principal type Futura
Dimensions 10½ x 5¼ in. (27 x 21 cm)

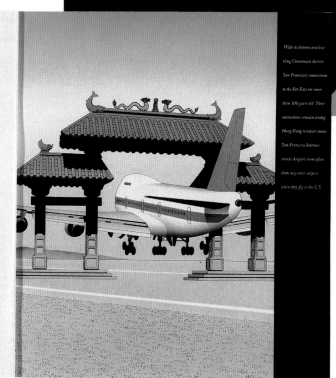

AIR TRAFFIC ACTIVITY

San Francisco International Airport continues to be the Bay Area's favorite airport. Served by 50 airlines, passengers can fly non-stop to 85 cities in the United States. Travellers also have tremendous choice in their international options, with the ability to fly direct to 34 international cities. ◈ In terms of total passengers, San Francisco International Airport is the seventh busiest airport in the United States. During Fiscal Year 1988/89, the Airport served nearly 31 million passengers—an all-time high. ◈ But while many of the nation's largest airports have grown in size as a result of increased hubbing activity, support for San Francisco International Airport continues to be locally based; approximately 75% of the passengers consider the Airport to be their primary origin or destination. As a result, San Francisco ranks third in the nation in terms of "origin and destination" passengers. ◈ In Fiscal Year 1988/89, the Airport's biggest gains came in the international arena. While total domestic passengers increased 1% from the previous year, international passenger traffic increased an impressive 7.2% during the same period. ◈ Total cargo traffic remained steady in Fiscal Year 1988/89, with 568,982 metric tons passing through the Airport. For the first time in the Airport's history, international cargo tonnage (not including U.S. mail) exceeded domestic tonnage. This important fact reveals once again that San Francisco is truly an important conduit for international business. ◈ The Airport averages 1,200 aircraft operations each day—more than one operation each minute during normal operating hours. During Fiscal Year 1988/89, aircraft landings and take-offs totalled 437,342. Commercial jet carriers accounted for over 70% of these flight operations. The rest involved commuter, military, and general aviation aircraft.

Nearly thirty-one million passengers passed through the Airport last year, making SFIA the seventh busiest airport in the United States.

With its historic and bustling Chinatown district, San Francisco's connections to the Far East are more than 100 years old. These connections remain strong; Hong Kong residents choose San Francisco International Airport more often than any other airport when they fly to the U.S.

Annual Report
Typography/Design Jennifer Morla and Marianne Mitten,
San Francisco, California
Typographic supplier Andresen Typographics
Studio Morla Design, Inc.
Client Francisco International Airports Commission
Principal types Futura Bold, Janson, and Copperplate Gothic 33B
Dimensions 9½ x 8½ in. (24.1 x 21.6 cm)

Poster
Typography/Design The Design Works,
 Toronto, Ontario, Canada
Typographic supplier Cooper & Beatty
Studio The Design Works
Client Clarke Hooper
Principal type Eurostile Bold Extended
Dimensions 8¼ x 11¾ in. (21 x 29.8 cm)

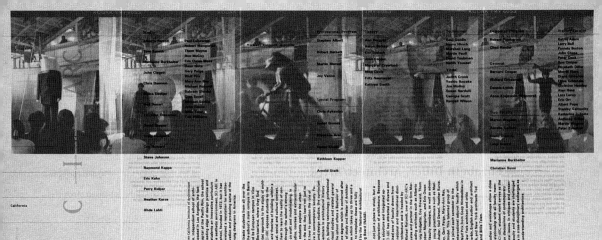

Studio		Professional Program	Theory	Technology	Graduate Program	Visiting Faculty
Wolfgang Puttnik	Paul Lubowicki	Stephen Albert	Ann Bergren	Saul Goldin	Robert Pennington	Kathi Adam
Tom Buresh	Robert Mangurian		Aaron Betsky	Henry Hirsch	Chad Oppenheim	Larry Ball
Andrew Burkhalter	Thom Mayne	Robert Barnett	Kari Irahish	Marshall Long		Pamela Burton
	Ron McCoy		Joan Cooper	Martin Pauli		John Chase
John Clagett	Eric Owen Moss	Martin Moraes	Margaret Crawford	David Taubman	General	Peter Cook
Chris Dawson	Dean Yota		Mike Davis	Nasih Youssef	Bernard Cooper	Coop Himmelblau
	Gary Paige	Jay Vance	Fritz Neumeyer	Gopal	Richard Cousens	Elizabeth Diller
Jessica Diedjon	Wolf Prix					Merrih Hinn
	Mary-Ann Ray		Judith Crook	Dennis Lynch	Diana Gibson	Frank Gehry
Neil Denari	Michael Rotondi		Yoshio Rozuka	Susan Narduli	Aura Krajewski-Macenzio	Ellen Greenstein
	Bahram Shirdel	Special Programs	Joe Molloy	Georgie Scott		Christine Hawley
William Dewant	Eric Johnson		Georgie Scott	Randall Wilson	York Faculty	Alan Hess
	John Gaither	Chris Aykanian	Randall Wilson		Marion Weaver	Lars Lerup
Alex Dumas					Aurelia Gaither	Eric Orr
	Cal Johnson	Janet Breen			Hani Stone	Albert Pope
					Luigi Sterzi	Stanley Saitowitz
						Katherine J. Sota
						Michael Sorkin
						Nancy Zaslavsky
						Peter Zoba

Steve Johnson	Michael Rotondi, Director	Kathleen Kupper	Marianne Burkhalter
Raymond Kappe		Arnold Stalk	Christian Sumi
Eric Kahn			
Perry Kulper			
Heather Kurze			
Ahde Lahti			

California

The Southern California Institute of Architecture is a private, independent school of architecture. Located in Los Angeles, the fastest growing region in the United States, the school is on the leading edge of design practice and architectural theory. SCI-Arc is an innovative curriculum taught in an intimate environment. SCI-Arc is a young school, founded in 1972, but it has already developed a reputation for architectural innovation and producing some of the leading young designers in America.

SCI-Arc attracts students from all over the world to the school's main campus in Santa Monica and the European campus in Vico Morcote, Switzerland. SCI-Arc has developed an integrated approach to the study of architecture. SCI-Arc exposes students to the latest ideas in architecture, but within a larger visual, social and cultural context, allowing them to learn the reality of construction from beginning to end. SCI-Arc places an emphasis on craft and modelmaking in design studios, courses and extracurricular activities, creating a spirit of exploration on the frontier. In the end, they learn not just to design but how to question the role of architecture in our lives. SCI-Arc includes seminars in architectural history and theory, building construction, professional practice, visual studies and related general studies. The school offers a Bachelor of Architecture which is earned in a five-year program and after five years of study and Master of Architecture degree which takes up to three and a half years to complete. SCI-Arc is accredited by the National Architectural Accrediting Board (NAAB).

SCI-Arc is not just a place to study, but a creative exploration of architecture. Because of its intense educational environment and approach, SCI-Arc has attracted a diverse and accomplished international faculty which has long enjoyed an international discipline of architecture and is headed by Director Michael Rotondi and co-founder of SCI-Arc, who graduates and partner in the firm Morphosis. Leading architects such as Alberto Betsky, Craig Hodgetts, Wolf Prix, Thom Mayne, Robert Mangurian, and Eric Owen Moss are faculty members, as well as international designers and theorists, such as Marianne Burkhalter, Saul Denari, Heather Kurze, Ron McCoy, Gary Paige, Mary-Ann Ray, Bahram Shirdel, and Michael Sorkin. A number of teachers is joined each semester by the school's international adjunct faculty which includes Coop Himmelblau of Vienna, New York architect and critic Michael Sorkin, English author and architect Peter Cook, and London architects Ted Williams and Billie Tsien.

Design studios and workshops allow a close working relationship with all faculty members here. At SCI-Arc, student work serves as the catalyst for discussion of social and architectural issues. In critiques and presentations, faculty and students are challenged to articulate their architectural positions as a way of understanding architecture.

S C I - A r c

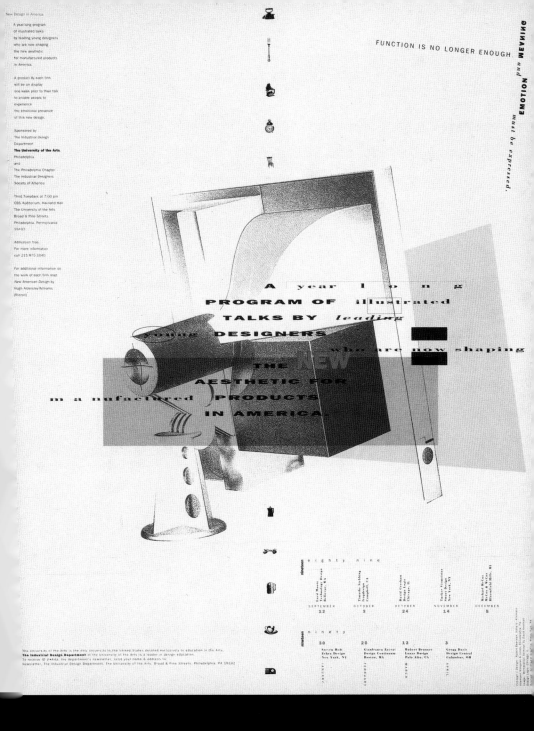

FUNCTION IS NO LONGER ENOUGH.

MEANING and EMOTION must be expressed.

New Design in America

A year-long program
of illustrated talks
by leading young designers
who are now shaping
the new aesthetic
for manufactured products
in America.

A product by each firm
will be on display
one week prior to their talk
to enable people to
experience
the emotional presence
of this new design.

Sponsored by
The Industrial Design
Department
The University of the Arts,
Philadelphia
and
The Philadelphia Chapter
The Industrial Designers
Society of America

Third Tuesdays at 7:00 pm
CBS Auditorium, Haviland Hall
The University of the Arts
Broad & Pine Streets
Philadelphia, Pennsylvania
19102

Admission free
For more information
call 215-875-1040

For additional information on
the work of each firm read
New American Design by
Hugh Aldersley-Williams
(Rizzoli)

A year long PROGRAM OF illustrated TALKS BY leading young DESIGNERS who are now shaping THE NEW AESTHETIC FOR manufactured PRODUCTS IN AMERICA.

The University of the Arts is the only university in the United States devoted exclusively to education in the Arts.
The Industrial Design Department at the university of the arts is a leader in design education.
To receive (6 yearly) the department's newsletter, send your name & address to:
Newsletter, The Industrial Design Department, The University of the Arts, Broad & Pine Streets, Philadelphia, PA 19102

Poster
Typography/Design **Robert Beerman and Hans-U. Allemann,**
Philadelphia, Pennsylvania
Typographic supplier **In-house**
Studio **Allemann Almquist & Jones**
Client **Industrial Design Department, University of the Arts**
Principal types **Franklin Gothic and Bodoni Bold**
Dimensions **17 x 22 in. (43.2 x 55.9 cm)**

AGOURON

PHARMACEUTICALS INC

ANNUAL

REPORT

Annual Report
Typography/Design **Rik Besser,**
Santa Monica, California
Typographic supplier **Composition Type**
Studio **Besser Joseph Partners, Inc.**
Client **Agouron Pharmaceuticals, Inc.**
Principal type **Garamond No. 3**
Dimensions **12 x 9½ in. (30.5 x 24.1 cm)**

We need to have places and processes that stimulate conversation.

The CDC is a focal point for using the exchange of understandings to shape the collaborative design of environments and design processes.

m anticipating pieces of our common fut

a set ting that allows ideas to grow . I ne

unde rstan ding is support ed by the

will come from being able to pl ay wi

d the chan ce to try out a voice I mig

hat w eaves freely in and out of a const

voice will .grow stronger, bit by bit, as

The flow of information is an organic process.

It is something that must be
built into an organization and
carefully encouraged through
the creation of places and the
implementation of activities.

Brochure
Typography/Design **Shirley Rogers and Fitch RichardsonSmith,**
Worthington, Ohio
Typographic supplier **In-house**
Studio **Fitch RichardsonSmith**
Client **Steelcase, Inc.**
Principal types **Sabon and Frutiger**
Dimensions **6 x 12 in. (15.2 x 30.5 cm)**

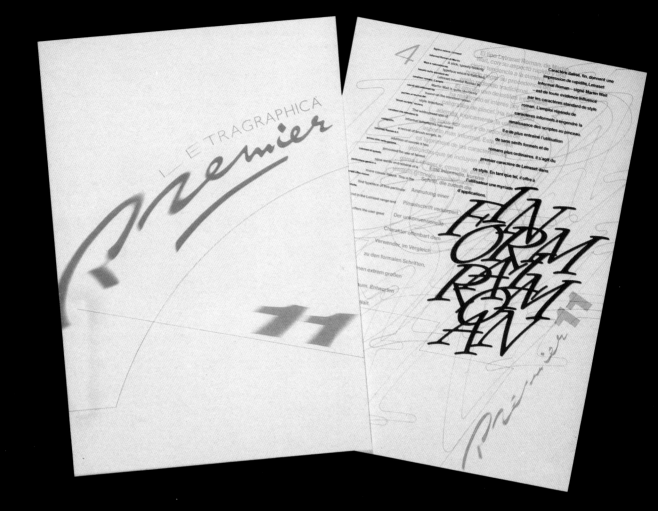

Brochure
Typography/Design **David Quay,**
London, England
Typographic supplier **Span Graphics Limited**
Studio **David Quay Design**
Client **Esselte Letraset**
Principal type **Helvetica**
Dimensions **13¾ x 9½ in. (35 x 24.2 cm)**

SOGRAPE
Reserva 1987
Douro
região demarcada
vinho branco
Engarrafado por
Sogrape Vinhos
de Portugal S.A.
Avintes Product of
Portugal 12.5% vol 75 cl.

Packaging
Typography/Design **Mary Lewis,**
 London, England
Calligraphers **Mary Lewis and Tom Perkins**
Agency **Lewis Moberly**
Client **Vinhos Sogrape do Portugal**
Principal type **Handlettering**
Dimensions 2⅜ x 2⅝ in. (6 x 6.7 cm)

Calendar
Typography/Design **Tatsuomi Majima,**
　　　　　　Tokyo, Japan
Letterer **Tatsuomi Majima**
Typographic supplier **Majima Design Inc.**
Agency **Gulliver Book**
Studio **Majima Design Inc.**
Client **Gulliver Co., Ltd.**
Principal types **Various and handlettering**
Dimensions **9⅞ x 5⅞ in. (25 x 14.8 cm)**

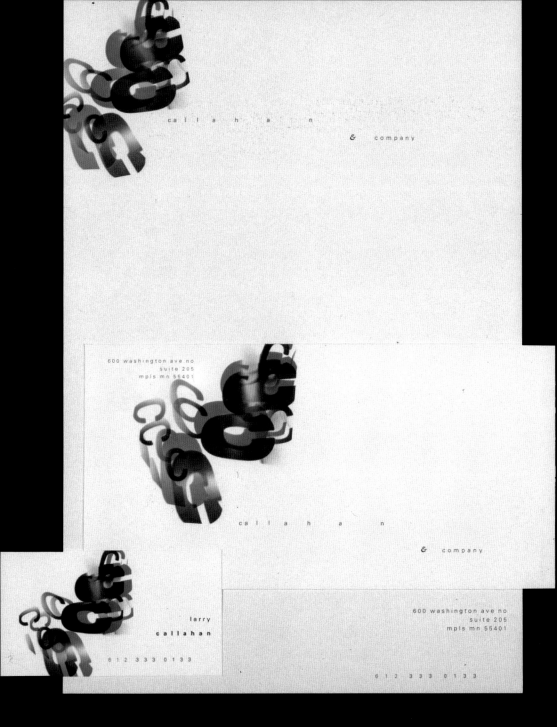

Stationery
Typography/Design **Dianne Yanovick,**
Minneapolis, Minnesota
Photographer **Dianne Yanovick**
Typographic supplier **Alphagraphics One**
Studio **Yanovick & Associates**
Client **Callahan & Company**
Principal type **Univers**
Dimensions 7⁵⁄₁₆ x 11 in. (18.6 x 27.9 cm)

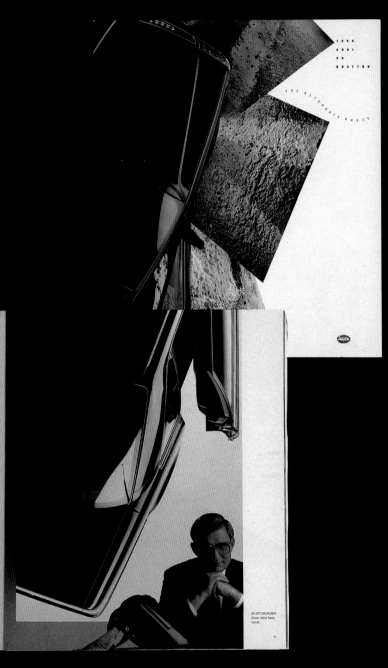

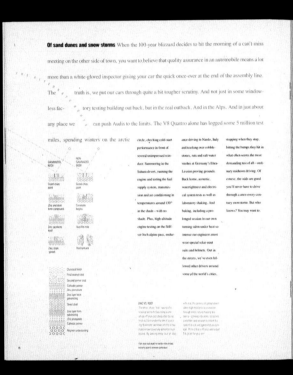

Brochure

Typography/Design **Miles Abernethy and Karin Burklein Arnold,**
Scottsdale, Arizona
Typographic supplier **In-house**
Agency **SHR Design Communications**
Client **Audi of America, Inc.**
Principal type **Times and Helvetica Condensed Light and Bold**
Dimensions **10¼ x 12 in. (26 x 30.5 cm)**

The business reply card (BRC) is the vehicle for, in sales terms, "asking for the order" or "closing the sale." How strongly the copywriter states that request depends on the products he's selling and the audience to whom he's speaking. Visually, the BRC is an important attention-getting device; often there are "involvement devices" to encourage customer response—we will cover these in a later chapter.

The business reply envelope (BRE), on the other hand, is primarily a production concern; this is a tactical matter, not a strategic one. This is the workhorse that actually brings back the customer's reply; it should be designed for efficiency and ease of response.

When your customer is not required to send in any information that is confidential, like credit information, then a BRC is the most cost-effective method of retrieving the information. The self-mailer by Pickett & Associates for the DHL Customs Primer has a really well-designed response card. It emphasizes that the product is free, has a nice clear area for the customer to fill out, and does double duty by picking up some valuable information about the customer, as well. They have used a dull coated stock, which is easy to fill out with ballpoint pen, and they made sure that the paper calipered .007, the minimum that the Post Office will presently accept for Business Reply Cards.

The return envelope designed for Bank of America's Apollo program (pictured on page 51) shows that the BRE can be designed to fit in with a whole cohesive package. It is printed on a cream vellum and looks very classy, but it meets all the format requirements. A return

Book
Typography/Design **Stephen Doyle, Rosemarie Turk, and Christopher Johnson,** *New York, New York*
Typographic supplier **Trufont Typographers and in-house**
Studio **Drenttel Doyle Partners**
Client **American Photography, Inc.**
Principal type **Cloister Old Style**
Dimensions **12 x 9½ in. (30.5 x 24.1 cm)**

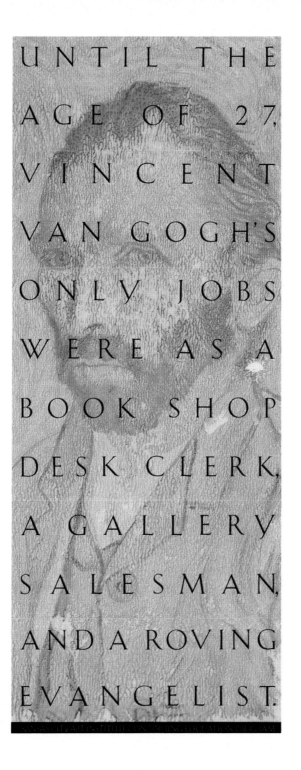

UNTIL THE AGE OF 27, VINCENT VAN GOGH'S ONLY JOBS WERE AS A BOOK SHOP DESK CLERK, A GALLERY SALESMAN, AND A ROVING EVANGELIST.

Brochure
Typography/Design **John Muller and Jane Weeks,**
Kansas City, Missouri
Letterer **Jane Weeks and Rich Kobs**
Typographic supplier **Cicero Typographers**
Studio **Muller & Company**
Client **Kansas City Art Institute**
Principal type **Bauer Text Initials and handlettering**
Dimensions **9¼ x 23¹⁵⁄₁₆ in. (23.5 x 60.8 cm)**

NANA WATANABE

IN FASHION PHOTOGRAPHY, SOMETIMES THE CLOTHES ARE THE STORY. OCCASIONALLY THE MODEL IS THE STORY. BUT IN THE CASE OF A SLIGHT, SERENE, SOFT-VOICED JAPANESE PHOTOGRAPHER NAMED NANA WATANABE, THE STORY HAPPENS TO BE THE VERY PRIVATE RELATIONSHIP BETWEEN THE PHOTOGRAPHER AND HER PICTURE. □ THERE ARE FEW SUCCESSFUL COMMERCIAL PHOTOGRAPHERS WHO WOULD ADMIT—EVEN IF IT WERE TRUE—THAT THEIR PRIMARY OBJECT IN THEIR WORK IS THEIR OWN PLEASURE. BUT THAT IS WATANABE'S DRIVING FORCE, AND IT CLEARLY INFORMS THE RESULT. "I TAKE PHOTOGRAPHS BECAUSE IT MAKES ME VERY HAPPY," SHE SAYS GENTLY. "IT EXCITES ME AND EXHILARATES ME, AND THAT'S A PLEASURE AND JOY I CAN NEVER EXPERIENCE IN MY DAILY LIFE IN OTHER ASPECTS. IF OTHER PEOPLE HAPPEN TO LIKE MY PHOTOGRAPHS, I'LL BE VERY PLEASED, BUT THAT'S NOT MY PURPOSE. TO SATISFY MYSELF, THAT'S MY PURPOSE." □ IF YOU WILL LEAVE YOUR SHOES AT THE DOOR, YOU MAY ENTER HER SPACIOUS APARTMENT BY MANHATTAN'S UNION SQUARE. THE ROOMS ARE SUFFUSED WITH LIGHT ENTERING BY LARGE WINDOWS FLUTTERING WITH LACE HALF-CURTAINS. COLORS AND TEXTURES ARE HARMONIOUS: THE THREE LUSH PINK PEONIES ON THE TABLE WITH THE PALE GRAY PILE CARPET WITH THE PLASTER CLASSICAL TORSO IN THE CORNER. THE OVERALL IMPRESSION IS

the intangible from many angles. A certain style, say surrealism, says a great deal about how a company looks at the world. Message is also inherent in the medium: an oil painting speaks of heritage, a charcoal sketch of a young business' energy. And the possibilities of paper for expressing the intangible are as vast as the spectrum of their color and texture range. Suggesting, subliminally, the intended image— strength, savvy, opulence or austerity. All the while, underscoring the individuality and ingenuity of the company itself. The choices in both art and the paper that frames it can suggest to the annual report reader a leading question: if the company is interesting aesthetically, might that carry through in the way they do business?

*E*ven when innovation seems the only order of the day, a deft creative hand reaches back into history for a traditional technique, style or medium—and uses it in a fresh, new way. ❧ Annual report illustration continues to surprise in the scope of subject matter as well. Today a farmer in his field says something about the American spirit suitable for a mortgage banker's book. ❧ The centuries-old woodcut technique provides an added dimension of authenticity. And the paper adds symbolic weight to the realization of the concept. Curtis Flannel has the feel and finish of a handmade fine art sheet, suggesting to the reader that what he holds in his hand is very much an original.

Annual Report
Typography/Design **Rex Peteet,** *Dallas, Texas*
Calligrapher **Rex Peteet**
Typographic supplier **Robert J. Hilton Company, Inc.**
Studio **Sibley/Peteet Design, Inc.**
Client **James River Corporation**
Principal type **Various**
Dimensions **8½ x 11½ in. (21.6 x 29.2 cm)**

M A R T E X

S P R I N G

1 9 9 0

Brochure
Typography/Design **James Sebastian and Junko Mayumi,**
New York, New York
Art Director **James Sebastian**
Typographic supplier **Typogram Inc.**
Studio **Designframe Inc.**
Client **West Point Pepperell/Martex**
Principal type **Syntax Black**
Dimensions **10 x 16 in. (25.4 x 40.6 cm)**

Brochure
Designers **James Sebastian and Junko Mayumi,**
New York, New York
Art Director **James Sebastian**
Typographic supplier **Boro Typographers**
Studio **Designframe Inc.**
Client **West Point Pepperell/Martex**
Principal type **Baskerville Book**
Dimensions **12 x 12 in. (30.5 x 30.5 cm)**

Calendar
Typography/Design **Lisa Levin,** *San Francisco, California*
Typographic supplier **In-house**
Studio **Lisa Levin Design**
Client **George Rice & Sons**
Principal types **Matrix Wide and Adobe Garamond**
Dimensions **7¼ x 9¼ in. (18.4 x 23.5 cm)**

Calendar
Typography/Design **Mark James,**
 Philadelphia, Pennsylvania
Typographic supplier **Duke & Company**
Studio **Allemann Almquist & Jones**
Client **Intracorp**
Principal types **Univers 75 and Garamond No. 3**
Dimensions **9 x 9 in. (22.9 x 22.9 cm)**

Calendar Book
Typography/Design Michel Cevey, Detlef Behr, Roger Quandel, and Silke Wolter,
Frankfurt am Main, West Germany
Typographic supplier typeshop gmbh
Agency CeveyConcept
Clients CeveyConcept and typeshop gmbh
Principal types Univers 45, Univers 65, Franklin Antiqua, and handlettering
Dimensions 8¼ x 8¼ in. (21.0 x 21.0 cm)

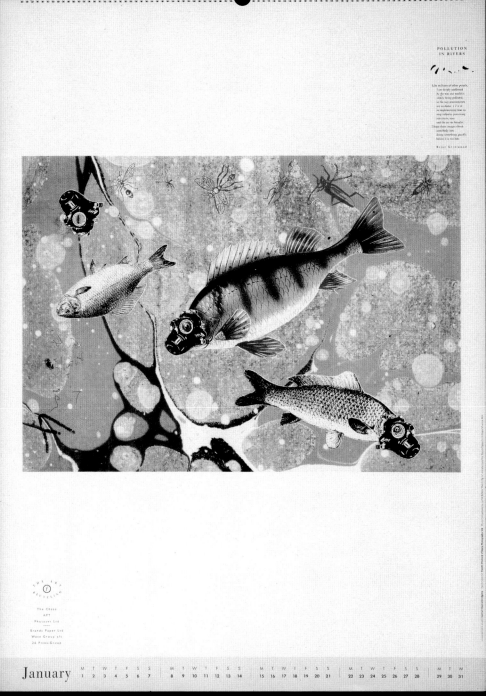

January

| M | T | W | T | F | S | S | | M | T | W | T | F | S | S | | M | T | W | T | F | S | S | | M | T | W | T | F | S | S | | M | T | W |
| 1 | 2 | 3 | 4 | 5 | 6 | 7 | | 8 | 9 | 10 | 11 | 12 | 13 | 14 | | 15 | 16 | 17 | 18 | 19 | 20 | 21 | | 22 | 23 | 24 | 25 | 26 | 27 | 28 | | 29 | 30 | 31 |

Calendar

Typography/Design **The Chase,**
Manchester, England
Typographic supplier **APT Photoset Ltd.**
Studio **APT Photoset Ltd.**
Client **APT Photoset Ltd.**
Principal type **Ehrhardt**
Dimensions **33 x 23½ in. (84.0 x 59.6 cm)**

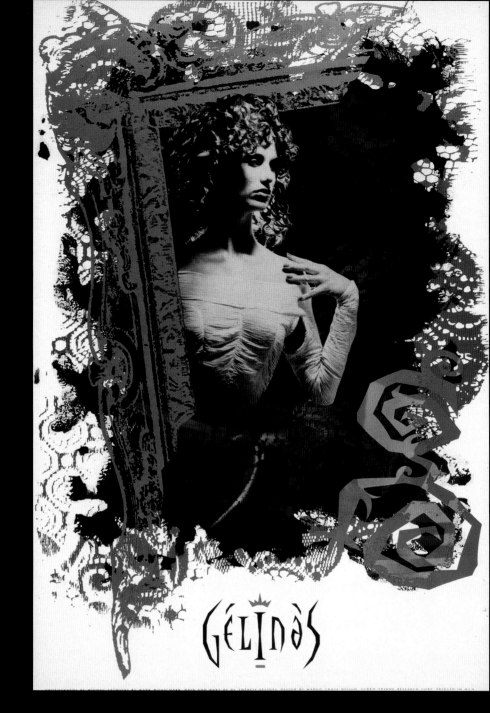

Campaign
Typography/Design **Margo Chase and Lorna Stovall,**
Los Angeles, California
Typographic supplier **Cliff Typographers**
Studio **Margo Chase Design**
Client **Triune Research**
Principal type **Manipulated Trajanus**
Dimensions **Various**

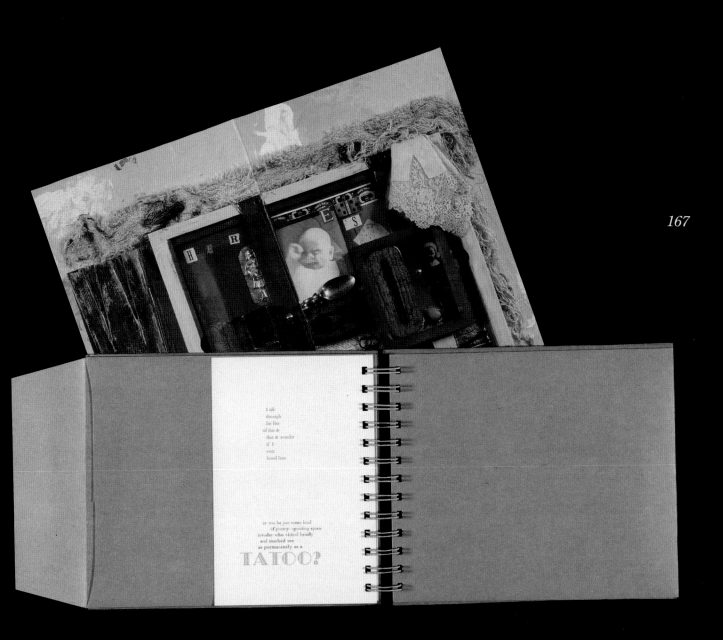

Brochure
Typography/Design Bruce Crocker and Mark Olson,
Boston, Massachusetts
Typographic supplier Innerer Klang Press
Studio Crocker, Inc.
Client Deborah Lipman Artist's Representative
Principal type Bembo
Dimensions 8⁵/₃₂ x 7³/₃₂ in. (20.7 x 18 cm)

Primo Levi was born in Turin in 1919 to an Italian-Jewish family. Arrested as a member of the anti-Fascist resistance, he was deported to Auschwitz in 1944. After the war, Levi resumed his careers as a chemist and a writer in Turin until his untimely death in 1986.

Raymond Rosenthal won the *Present Tense* award for his translation of Primo Levi's *The Periodic Table*. He lives in New York City.

Translated by Raymond Rosenthal
Jacket photograph by Giansanti/Sygma
Jacket design by Louise Fili
Schocken Books, New York
10/89 Printed in the U.S.A. © 1989 Random House, Inc.

THE MIRROR MAKER

PRIMO LEVI

Schocken

PRIMO LEVI
THE MIRROR MAKER

STORIES & ESSAYS

FPT $16.95

With the publication in 1985 of *The Periodic Table*, Primo Levi became one of America's most beloved writers. This new collection of short stories and essays by Levi reveals the great Italian writer's full imaginative range and keen sense of humor.

Most of the stories are science fiction and fantasy, combining Levi's love for science with his perceptions of human nature. The title story tells of a young man who inherits his family's business of making mirrors. Seeking to add a personal touch to his craft, he begins to invent mirrors that reflect in unusual ways, including a mirror that reflects how others see you. He gives the first one to his fiancée, after which the relationship rapidly dissolves.

These funny, fanciful tales always reward us with fresh perspectives on human life. The essays, originally published in the Italian newspaper *La Stampa*, cover a broad range of topics, from art to writing and current events. Levi's quick wit and humanity shine through in these gemlike pieces.

"There are writers, a few of them, who stir an immediate personal response. For me, the Italian-Jewish memoirist and novelist Primo Levi is such a writer. . . . He is a writer of integrity, seriousness, and charm."
— Irving Howe

Book Cover
Typography/Design Louise Fili, *New York, New York*
Typographic suppliers Photo-Lettering, Inc., Maxwell Typographers, and Vladimir Studio Random House Inc.
Client Schocken Books
Principal types Columbus Condensed No. 4 and handlettering
Dimensions 5⁹⁄₁₆ x 8⁷⁄₁₆ in. (14.1 x 21.4 cm)

PAUL PRICE PHOTOGRAPHY
2292
COLE STREET
BIRMINGHAM
MI PHOTOGRAPHY
48008

313 642 8884 642 9710 FAX

Paul Price

RICE PHOTOGRAPHY
2292
COLE STREET
BIRMINGHAM
MI PHOTOGRAPHY
48008

Paul Price

PAUL PRICE PHOTOGRAPHY
2292
COLE STREET
BIRMINGHAM
MI PHOTOGRAPHY
48008

313 642 8884 642 9710 FAX

Paul Price

Stationery
Typography/Design **James A. Houff,** *Grosse Pointe, Michigan*
Typographic supplier **In-house**
Studio **James A. Houff Design**
Client **Paul Price Photography**
Principal type **Magnum Gothic Light**
Dimensions 8¼ x 11 in. (21.6 x 27.9 cm)

THE ART OF THE
INUIT

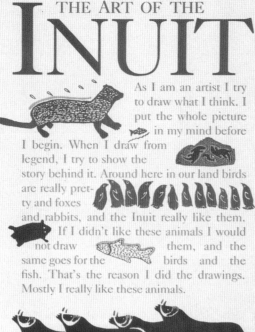

As I am an artist I try to draw what I think. I put the whole picture in my mind before I begin. When I draw from legend, I try to show the story behind it. Around here in our land birds are really pretty and foxes and rabbits, and the Inuit really like them. If I didn't like these animals I would not draw them, and the same goes for the birds and the fish. That's the reason I did the drawings. Mostly I really like these animals.

CALLING ALL THE ANIMALS

TEXT: TAKEN FROM EXCERPTS OF INTERVIEWS WITH INUIT ARTISTS. DESIGN: THE NATURE COMPANY. PRINTING: JOUR HOLLAND PRINTERS. THE NATURE COMPANY APPRECIATES THE SPONSORSHIP SUPPORT OF THE CANADA-NORTHWEST TERRITORIES ECONOMIC DEVELOPMENT AGREEMENT: ARTS AND CRAFTS SUB-AGREEMENT. © THE NATURE COMPANY 1990

Invitation/Poster
Typography/Design Christina Donna, *Berkeley, California*
Art/Illustration Adapted from Inuit artists
Typographic supplier Ann Flanagan Typography
Studio The Nature Company
Clients Wruble Gallery and The Nature Company
Principal type Caslon 540
Dimensions 4 x 9⅛ in. (10.6 x 23.2 cm)

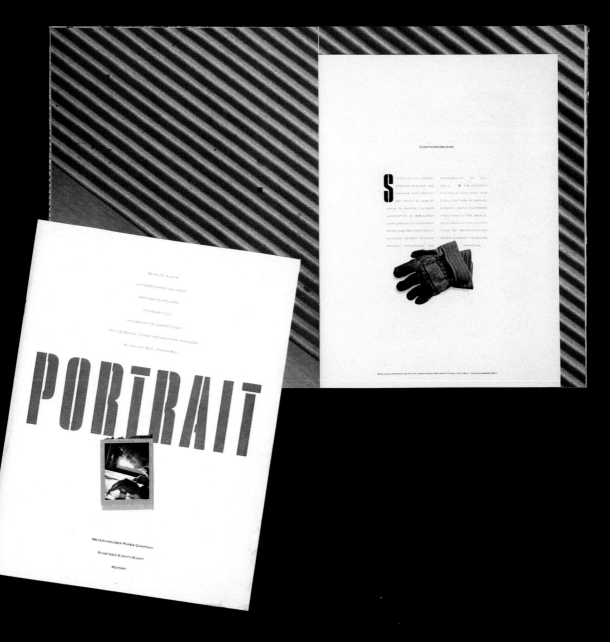

Annual Report
Typography/Design **John Van Dyke,**
 Seattle, Washington
Typographic supplier **Typehouse**
Agency **Van Dyke Company**
Client **Weyerhaeuser Paper Company**
Principal type **Copperplate Gothic 32 B/C**
Dimensions **9 x 12 in. (22.9 x 30.5 cm)**

JIM JENNINGS ARKHITEKTURE

JIM JENNINGS ARKHITEKTURE

25 BRUSH PLACE · SAN FRANCISCO · CA · 94103 · 415/255/1514

Stationery
Typography/Design **Michael Vanderbyl,**
San Francisco, California
Typographic supplier **Hester Typography**
Studio **Michael Vanderbyl Design**
Client **Jim Jennings Arkhitekture**
Principal types **Futura and Centaur**
Dimensions **8½ x 11 in. (21.6 x 27.9 cm)**

MacWEEK

1 9 9 0

174

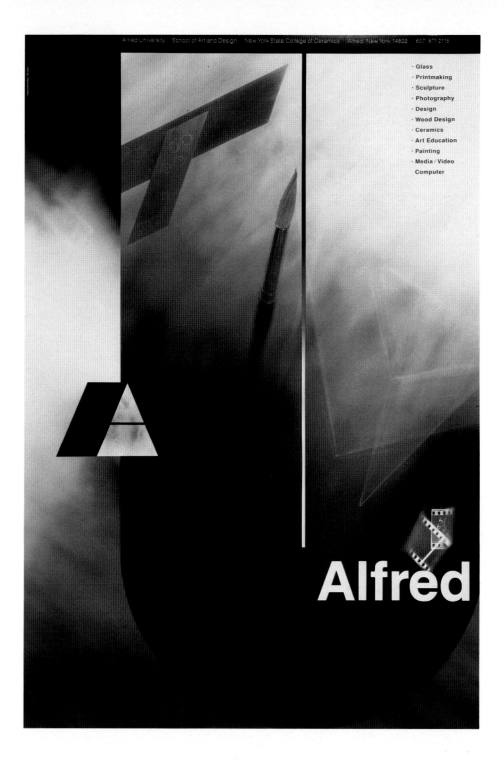

Poster
Typography/Design **Ramona Hutko,** *Alfred, New York*
Photographer **Ramona Hutko**
Typographic supplier **New York State College of Ceramics, Design Division**
Studio **Ramona Hutko Design**
Client **NYSCC at Alfred University**
Principal type **Helvetica**
Dimensions **20 x 30 in. (50.8 x 76.2 cm)**

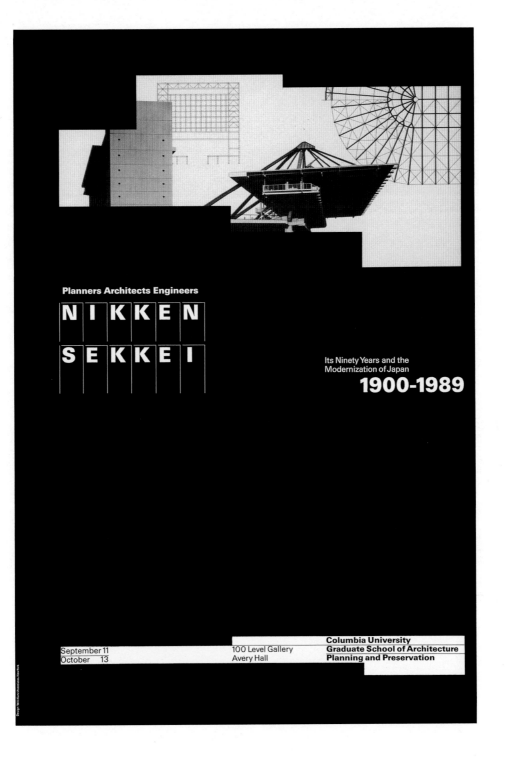

Poster
Typography/Design **Willi Kunz,** *New York, New York*
Typographic supplier **Typogram Inc.**
Agency **Willi Kunz Associates, Inc.**
Client **Nikken Sekkei, Tokyo**
Principal type **Univers**
Dimensions **18 x 27 in. (45.7 x 68.6 cm)**

Current Affairs $15.95

"An extraordinarily perceptive analysis of Chinese foreign policy, written by a very able group of young Chinese scholars who have studied in the United States. It is among the best recent books on the subject written by any scholars, but it is unique and of exceptional interest because it presents the analysis and judgments of a group of young scholars who have successfully bridged the gap between thinking in China and in the West. Many of the authors will doubtless play a significant role in shaping Chinese thinking about foreign policy in the future. These young scholars have absorbed the results of the best research in both the West and China, and use sources in both English and Chinese. Most important, they have presented their own independent judgments. With remarkable balance and objectivity, they assess past and present Chinese foreign policy, examine options for the future, and put forward concrete policy recommenda- tions. Their views deserve to be widely read in the West, and hopefully in China as well."
— A. Doak Barnett, Johns Hopkins University

"People are wondering about the consequences of America's educating so many Chinese intellectuals in our universities. One answer to that question is provided in these essays on China's foreign policy written by young Chinese scholars trained in the United States. The world is gaining a community of experts who will enhance foreign understanding of China and who will demand that their leaders explain their policies in more forthright terms."
— Professor Michel Oksenberg, University of Michigan

"This volume is a collection of extremely thoughtful essays on Chinese foreign policy by some of the more than two hundred Chinese students in the United States studying international relations. It is therefore a unique and welcome contribution to the study of Chinese foreign policy. Particularly at a time when China seems to be entering a period of instability, these essays should command a broad Western audience."
— Professor Donald Zagoria, Hunter College

"These essays combine the analytical rigor of Western political science with distinc- tively Chinese perspectives, and include independent prescriptions for the future of Chinese foreign policy. The book is an important contribution to the study of contempo- rary Chinese international relations, as well as being an introduction to an emerging generation of Chinese foreign-affairs analysts."
— Harry Harding, senior fellow, Brookings Institution

Also available in a Pantheon hardcover edition

Cover design by Henry Sene Yee

Pantheon Books, New York

9/89 Printed in the U.S.A. © 1989 Random House, Inc.

ISBN 0-679-72283-1

9 780679 722830
51595

HAO · KUAN

THE

THE CHINESE VIEW OF THE WORLD

THE CHINESE VIEW OF THE WORLD

EDITORS

PANTHEON

YUFAN HAO · GUOCANG HUAN

Book Cover
Typography/Design **Henry Sene Yee,** *New York, New York*
Typographic supplier **Maxwell Typographers**
Client **Pantheon Books**
Principal type **Oblong Regular**
Dimensions **6⅛ x 9¼ in. (15.5 x 23.5 cm)**

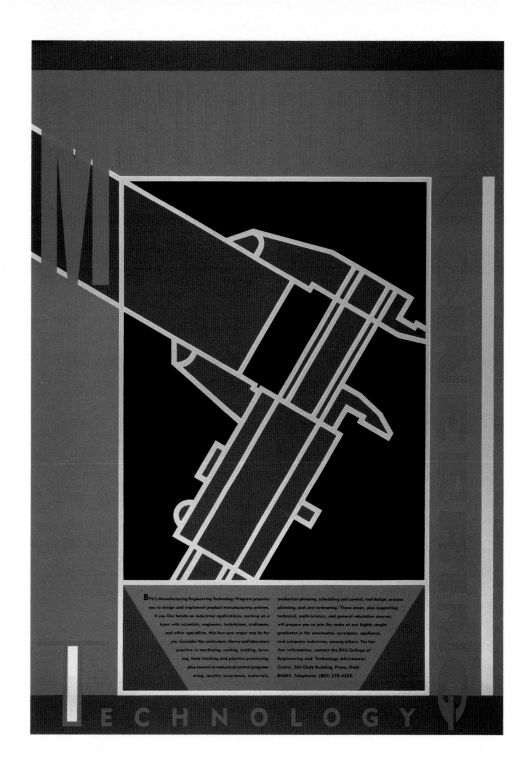

177

Poster

Typography/Design **Lily McCullough and McRay Magleby,**
Provo, Utah
Typographic supplier **In-house**
Studio **BYU Graphics**
Client **BYU Manufacturing Engineering Technology Department**
Principal type **Metroblack**
Dimensions **19½ x 28½ in. (49.5 x 72.4 cm)**

*C*apturing the interest of researchers, healthcare professionals and the general public is a daily concern. ⊙ An on-going part of ALS/A's information programs is attendance at major neurological conferences and scientific symposiums. Through discussions and distribution of materials we aim to attract researchers to join us in the search for the cause and cure of ALS. ⊙ At health fairs, civic and business organization meetings, chapters and support groups are using the ALSA video "A Thief in the Night" featuring Michael Gross, ALSA national spokesperson, as narrator. This ten-minute film describes the disease, its widespread devastation and the efforts of ALSA in providing help and hope to ALS victims. ⊙ Similarly, The ALS Association released several television public service announcements (PSAs) promoting the association and its fight against ALS to hundreds of television stations throughout the U.S. The filmed messages feature Michael Gross and the cast of "Family Ties." Over 200 million viewers have had access to ALS/A's messages and response to the 800-number displayed in the announcements has been overwhelming.

At the Society for Neuroscience meeting in Toronto, Canada, The ALS Association exhibit generates a great deal of interest among doctors and scientists wanting more information on ALSA's Research Grant program from Richard Doscen, ALSA VP-Communications.

In the national office Mary Beth Stove, ALSA VP-Development, supporting research from another perspective— prepares direct mail campaign materials for The ALS Association Research Council.

In between counseling ALSA chapters and support groups, Field Services VP Dee Dee Lowland plans chapter involvement in ALSA's 50th Anniversary Tribute to Lou Gehrig— a team effort with Major League Baseball to raise public awareness and funds in the fight against ALS.

*A*t the local level ALSA chapters have been successful in their own public information/awareness programs, including locally produced public service announcements, press coverage of fundraising events, guesting on area radio and television talk shows, and holding informational seminars. ⊙ Through these education, information and awareness building activities we set in motion a variety of responses, many of which will have lasting effects. Among these: a renewed dedication to cutting-edge ALS-specific research, heightened determination to provide the ultimate in state-of-the-art patient care, an expanded volunteer network to include those who have no direct experience with ALS, and most important, new sources of funding…that makes all other activities possible.

Tall palm trees swaying in warm, tropical breezes. Pink sand beaches blending into crystal clear water. Fragrances of honeysuckle and oleander filling the air. Sound like a typical British colony? The bright and beautiful islands of Bermuda are hardly typical. But, dear chaps, they do, in fact, compose the oldest British colony in the world.

Despite the allure of Bermuda, its first visitors weren't there by choice. The British vessel *Sea Venture* shipwrecked on Bermuda in 1609, and its 150 passengers washed onto an exquisite setting.

Today, Bermuda beckons visitors—sans treacherous landings—to explore its intrigue, romance

Governor Sir John Henry LeFroy
LeFroy launched Bermuda tourism in 1872 with the start of steamship service to New York.

HIGH SOCIETY AT SEA LEVEL
The British seized the royal opportunities Bermuda had to offer, including a chance for the well-heeled to settle on the island. In 1883, Princess Louise, daughter of Queen Victoria, came to Bermuda to escape the wintry climate of Canada, where her husband was the governor-general. Now the Crown Colony had its very own princess. And not coincidentally, the colony soon begat its first hotel—the Princess Hotel—in Hamilton. Catering to the rich and famous of the era, the hotel provided the finest amenities and drew many tourists.

Thus began a trend that lasted until World

BERMUDA

and dashing good looks that have been further enhanced through three centuries of British influence.

HUMBLE BEGINNINGS
The island was uninhabited when the *Sea Venture*'s passengers, led by Sir George Somers, were shipwrecked off what is now St. Catherine's Beach in 1609. After spending nearly a year on Bermuda, the castaways set sail for their original destination of Jamestown, Virginia.

Upon arrival at Jamestown, Sir George arrived to find the inhabitants there sick and starving. He decided to return to Bermuda for more food, and there he died of exhaustion. His nephew, Matthew Somers, buried the heart of Sir George near the island's 1609 landing site and carried the corpse back to England.

Swashbuckling stories of "Somers's Island" spread through London like wildfire, and letters of adventure about the alluring island quickly circulated. One fascinated reader—William Shakespeare—even based his play *The Tempest* on the tales.

Clipper Ship
Surrounded by welcoming blue oceans and sturdy red cedar, and infused with the maritime blood of the British, early Bermudians became acclaimed shipbuilders—and occasional pirates.

War II. During the winter, those who could afford it came to Bermuda for "the season," with their maids, steamer trunks and the latest in fashions.

A tropical version of British aristocracy bloomed, replete with horse-drawn carriages, high tea and croquet. Far from the white cliffs of Dover, the blue Caribbean served as a backdrop for Bermuda's winter residents.

Tennis found a loyal following. A century before British court champion Virginia Wade won her Wimbledon title, the island hosted the Western Hemisphere's first tennis tournament.

Other local sports that reflect British traditions include sailing, soccer and cricket. So popular is cricket, in fact, that every year the Cup Match between the island's two cricket teams is deemed an official holiday.

Naturally, the Princess Hotel could not accommodate everyone who flocked to Bermuda. Larger and newer hotels sprang up around the island, and with them, fine tennis courts and golf courses.

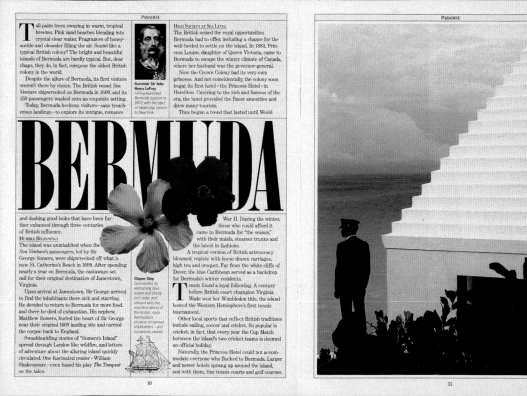

10

11

Magazine
Typography/Design Kit Hinrichs and Terri Driscoll, *San Francisco, California*
Art Director Kit Hinrichs
Calligrapher Georgia Deaver
Typographic supplier EuroType
Studio Pentagram Design
Client Royal Viking Line
Principal types Century Expanded and handlettering
Dimensions 8½ x 11 in. (21.6 x 27.9 cm)

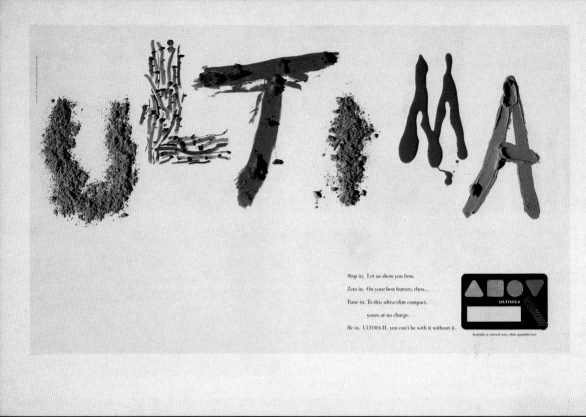

Advertisement
Typography/Design **Kiyoshi Kanai,**
 New York, New York
Photographer **Irving Penn**
Letterer **Irving Penn**
Typographic supplier **Typogram Inc.**
Studio **Kiyoshi Kanai, Inc.**
Client **Ultima II/Revlon**
Principal types **Cosmetics and Bodoni**
Dimensions **10⅞ x 18 in. (27.6 x 45.7 cm)**

Regulatory Matters Federal regulatory changes continue to be the primary source of uncertainty in the natural gas industry. This year, the Federal Energy Regulatory Commission's (FERC) initiatives for restructuring the gas industry met significant court opposition.

In late summer, the FERC order that raised ceiling prices for "old" gas found before 1973 (Order 451) was overturned. The appeals court determined that FERC lacked the statutory authority to issue the order. Our utilities supported the order's overturning, which could result in refunds to customers. FERC, however, has filed a request for rehearing, and it could be some time before the matter is resolved.

Just recently, Order 500, a so-called interim order issued in 1987 that promotes gas transportation service by interstate pipelines into traditional sales markets, was remanded by the U.S. Court of Appeals to FERC. The Court directed FERC to issue a final order within 60 days of the remand. The final order must address legal flaws in Order 500, including the manner in which FERC has handled pipeline take-or-pay obligations to producers. As with Order 451, our utilities were among those that sought this court review.

Notwithstanding the uncertain status of FERC's industry-wide initiatives, our companies were able to fashion agreements with their pipeline suppliers that would terminate pending general rate proceedings. One of these settlements, with Natural Gas Pipeline Company of America (Natural), our utilities' chief pipeline supplier, has now been approved by FERC. Awaiting FERC action are settlements for proceedings for Peoples Gas' other pipeline supplier, Midwestern Gas Transmission Company, and of Tennessee Gas Pipeline Company, Midwestern's major supplier. These agreements should help keep our utilities' costs reasonable and their service reliable.

Also, Natural filed with FERC an application for authority to introduce a form of "gas inventory charge," intended to compensate Natural for the cost of holding gas supply sufficient to meet the service level reserved by customers. Our companies, like most other customers of Natural, supported the concept of such charges but objected

CONVENIENCE

In such process applications as commercial baking, no other energy can beat the convenience and controllability of natural gas.

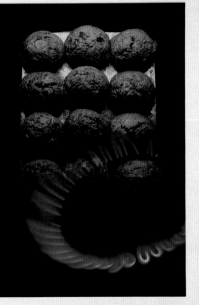

"If i had my own place,

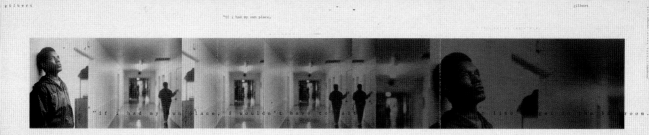

"if i had my own place, i wouldn't have to wait in line to get in the bathroom."

i wouldn't have to wait in line to get in the bathroom."

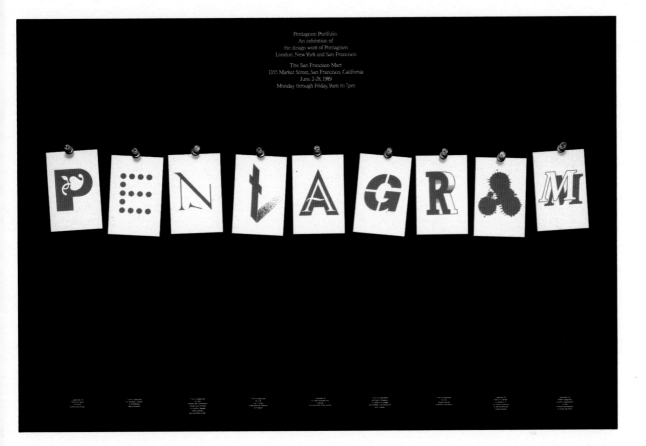

Poster
Typography/Design **Neil Shakery,**
San Francisco, California
Typographic supplier **Reardon & Krebs**
Studio **Pentagram Design**
Client **Pentagram Design**
Principal types **Times Roman and Helvetica**
Dimensions **22 x 32 in. (55.9 x 81.3 cm)**

Packaging
Typography/Design **Peter Locke,**
San Francisco, California
Typographic supplier **In-house**
Studio **Paul Curtin Design**
Client **Lapis Technologies, Inc.**
Principal types **Modula Serif Bold and Emigre 15**

Invitation
Typography/Design **Tim Thompson, Morton Jackson, Joe Parisi,
and Dave Plunkert**, *Baltimore, Maryland*
Letterer **Dave Plunkert**
Typographic supplier **In-house**
Studio **Graffito, Inc.**
Client **Graffito, Inc.**
Principal types **Futura, News Gothic, and Garamond No. 3**
Dimensions **5½ x 5½ in. (14 x 14 cm)**

WHATEVER YOU CAN DO,

OR DREAM YOU CAN,

B E G I N

i t .

BOLDNESS HAS GENIUS,

POWER AND MAGIC IN IT.

—JOHANN WOLFGANG VON GOETHE

GREAT FACES *The Artists In Advertising Typography* MINNEAPOLIS 1989

Greeting Card

Typography/Design **John Seymour-Anderson,**
Minneapolis, Minnesota

Typographic supplier **Great Faces, Inc.**

Agency **McCool & Company**

Client **Great Faces, Inc.**

Principal types **Weiss and Weiss Bold**

Dimensions **10⅝ x 9¾ in. (27 x 24.8 cm)**

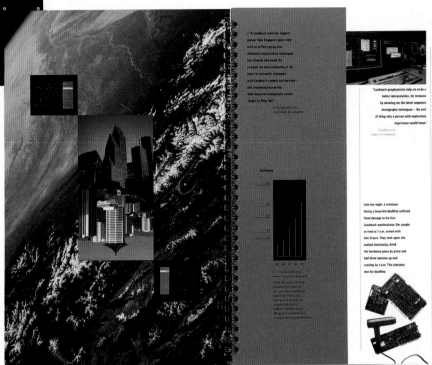

Annual Report
Typography/Design **Kenny Garrison,** *Dallas, Texas*
Typographic supplier **Characters Typography, Inc.**
Studio **Richards Brock Miller Mitchell and Associates**
Client **Landmark Graphics Corporation**
Principal types **Bembo and Helvetica Bold Condensed**
Dimensions **7½ x 11¾ in. (19.1 x 29.8 cm)**

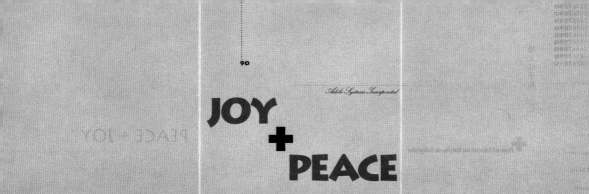

JOY
+
PEACE

Invitation
Typography/Design **Eric Pike,** *New York, New York*
Printer Solo **Letterpress**
Art Director **James Sebastian**
Typographic supplier **Typogram Inc.**
Studio **Designframe Inc.**
Client **Frank Fiore Design Inc.**
Principal types **Trump Mediaeval and hand-drawn logotype**
Dimensions **4¾ x 6¾ in. (12.1 X 17.2 cm)**

Put Your Best Foot Forward on Signature from Mead

Signature in a bright white,
number-one coated paper

191

Catalog
Typography/Design **John Cleveland,**
Santa Monica, California
Typographic supplier **Phototype House**
Agency **Bright & Associates**
Client **S. D. Warren Company**
Principals types **Bodoni Book and Futura Bold**
Dimensions **7 3/4 x 12 in. (19.7 x 30.5 cm)**

[Milan.
The Duke's palace.]
Enter
Duke,
Thurio,
[and] Proteus.

A

C

DUKE. *Sir Thurio, give us leave, I pray, awhile;*

We have some secrets to confer about. [EXIT THURIO.]

Now, tell me, Proteus, what's your will with me?

PROTEUS. *My gracious lord, that which I would discover*

The law of friendship bids me to conceal;

But when I call to mind your gracious favors

Done to me, undeserving as I am,

My duty pricks me on to utter that

Which else no worldly good should draw from me.

Know, worthy prince, Sir Valentine, my friend,

This night intends to steal away your daughter.

Myself am one made privy to the plot.

I know you have determined to bestow her

On Thurio, whom your gentle daughter hates,

And should she thus be stol'n away from you,

It would be much vexation to your age.

Thus, for my duty's sake, I rather chose

To cross my friend in his intended drift

Than, by concealing it, heap on your head

T

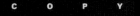

The four Univers typefaces are used for specific copy elements. The following provides specifications for each element. With the exception of legal or warning copy and the word REMANU-FACTURED, the size of type used is based on the cap height of the brandmark appearing on the package panel.

Product Name

Typestyle: Univers 49

Size: 1/4 brandmark cap height

Leading: 1/2 brandmark cap height

Letterspacing: + 18 units

Case: All upper case

Descriptive or Feature Copy

Typestyle: Univers 75

Size:

Less than 7 pica brandmark cap height, 8 pt.

7 pica to 10 pica brandmark cap height, 14 pt.

10 pica to 15 pica brandmark cap height, 20 pt.

15 pica to 20 pica brandmark cap height, 28 pt.

20 pica to 25 pica brandmark cap height, 36 pt.

Leading: 1/3 brandmark cap height

Letterspacing: -1 unit

Case: Upper and lower case

Part Number

Typestyle: Univers 85

Size: 1/4 brandmark cap height

Leading: 1/2 brandmark cap height

Letterspacing: 0

Case: Upper case

Legal or Warning Copy

Typestyle: Univers 57 (Recommended)

Minimum legal requirements should be followed while maintaining legibility. Copy should be set solid with -1 unit letterspacing.

Remanufactured

Typestyle: Univers 75

Refer to the following page for complete specifications.

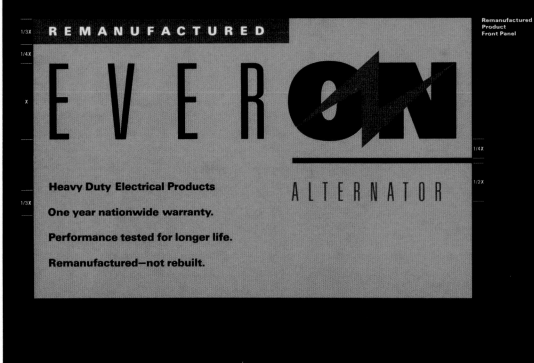

Remanufactured
Product
Front Panel

Corporate Identity Manual

Typography/Design **Mary Brucken,**
San Francisco, California

Typographic suppliers **EuroType and Reardon & Krebs**

Agency **SBG Partners**

Client **Paccar**

Principal type **Univers**

Dimensions **8½ x 11 in. (21.6 x 27.9 cm)**

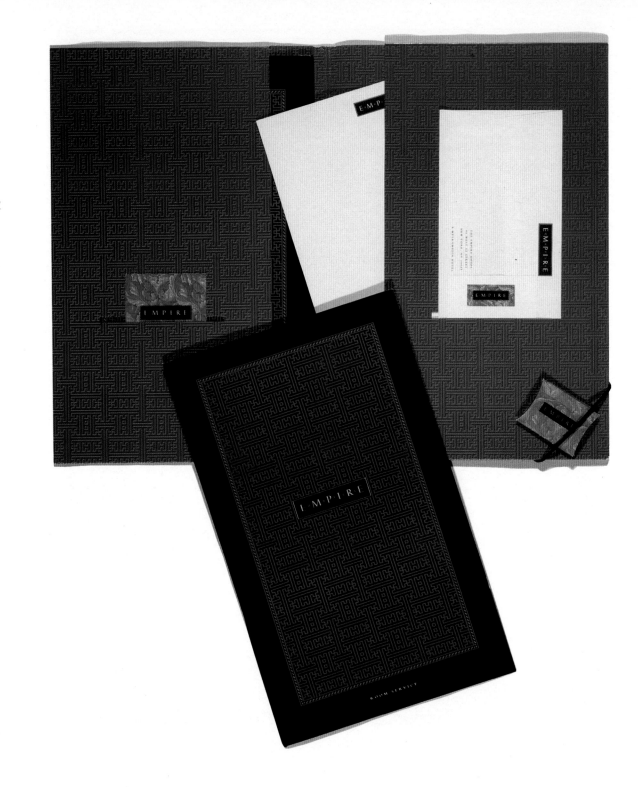

Corporate Identity
Typography/Design **Peter Harrison, Michael Gericke,
and James Anderson,** *New York, New York*
Typographic supplier **Maxwell Typographers**
Studio **Pentagram Design**
Client **Metromedia Hotels**
Principal types **Delphian Open and Futura Extra Bold**
Dimensions **Various**

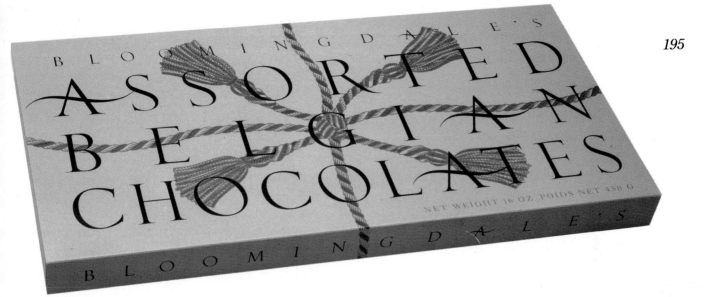

Packaging
Typography/Design **Robert Valentine,**
New York, New York
Agency **Bloomingdale's Special Projects**
Client **Bloomingdale's**
Principal type **Roman Capital**
Dimensions **16½ x 8 in. (41.9 x 20.3 cm)**

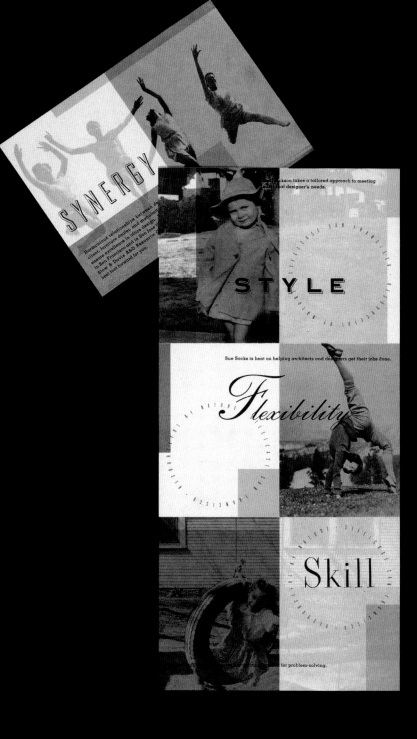

Direct Mail
Typography/Design Cinnie Worthington,
San Francisco, California
Art Director John Bricker
Typographic supplier Andresen Typographics
Studio Gensler and Associates/Graphics
Clients Steelcase, Inc., and Stow & Davis
Principal types Various typositor display
Dimensions 5¼ x 7½ in. (13.4 x 19 cm)

W O M E N I N

An Exhibit

February, 1990

Republic Plaza Lobby

Denver, Colorado

A M E R I C A N

A R C H I T E C T U R E

1 8 8 8 - 1 9 9 0

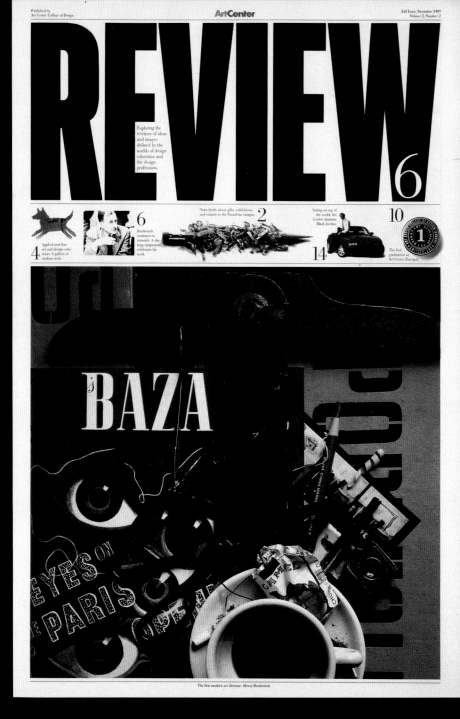

Newsletter

Typography/Design **Kit Hinrichs and Terri Driscoll,**
San Francisco, California
Art Director **Kit Hinrichs**
Typographic **supplier EuroType**
Studio **Pentagram Design**
Client **Art Center College of Design**
Principal type **Bodoni Antiqua**
Dimensions **11 x 17 in. (27.9 x 43.2 cm)**

JOHN CHEEVER

Book Cover

Typography/Design **Carin Goldberg,** *New York, New York*

Typographic supplier **The Type Shop**

Studio **Carin Goldberg Design**

Client **Harper and Row**

Principal types **Agency Gothic (Beautiful Faces brochure) and Greco Bold**

Dimensions **5⁵⁄₁₆ x 8 in. (13.5 x 20.3 cm)**

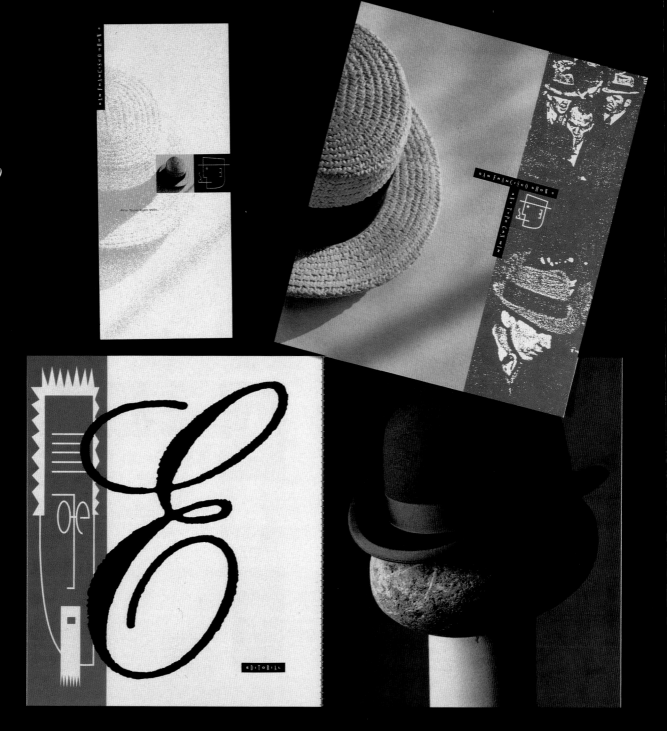

Book
Typography/Design **Steven Tolleson and Bob Aufuldish,**
San Francisco, California
Typographic supplier **Spartan Typographers**
Studio **Tolleson Design**
Client **San Francisco Show 3**
Principal types **Helvetica and Bodoni**
Dimensions **8½ x 10 in. (21.6 x 25.4 cm)**

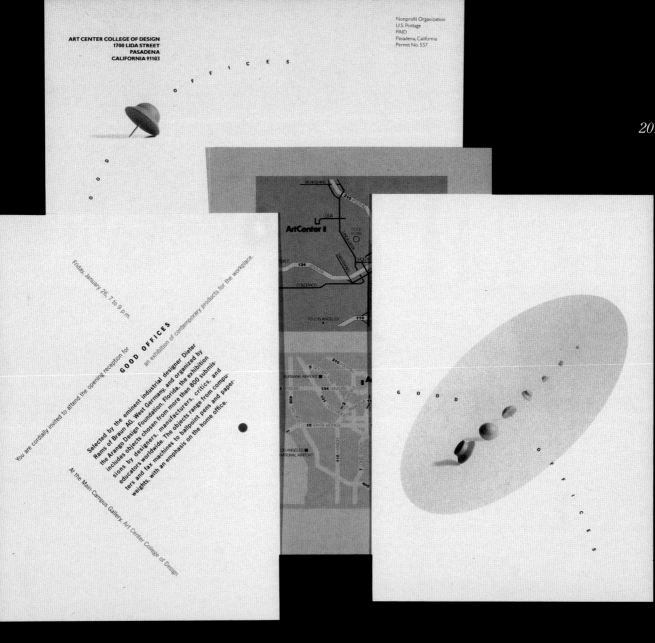

Invitation
Typography/Design **Rebeca Mendez and Sze Tsung Leong,**
Los Angeles, California
Typographic supplier **Dee Typographers Inc.**
Studio **Art Center College of Design, Design Office**
Client **Art Center College of Design**
Principal type **News Gothic**
Dimensions **7 x 5 in. (17.8 x 12.7 cm)**

Invitation
Typography/Design **Terry Koppel,** *New York, New York*
Typographic supplier **In-house**
Studio **Koppel & Scher, Inc.**
Client **David Hurwith**
Principal types **Bodoni Bold, Futura Bold, and various wood faces**

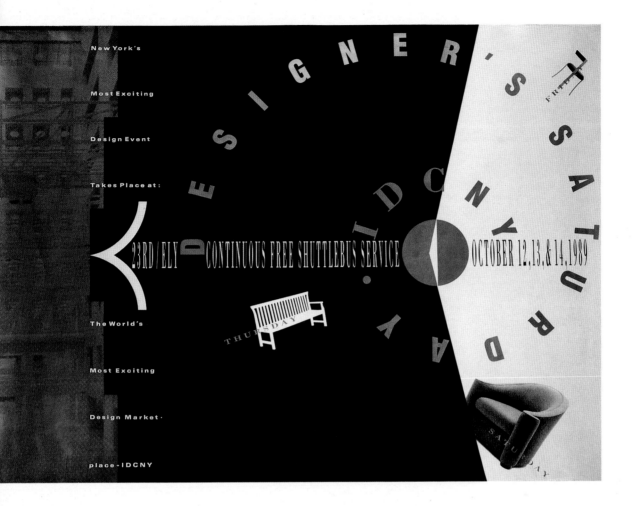

Poster
Typography/Design **Rick Biedel,**
New York, New York
Typographic supplier **Typogram Inc.**
Agency **Bonnell Design Associates**
Client **International Design Center New York**
Principal types **Univers and Bodoni**
Dimensions **44½ x 59¼ in. (113 x 150.5 cm)**

Magazine Cover
Typography/Design Risa Zaitschek and Jeanine Esposito,
New York, New York
Typographic supplier **In-house**
Studio **Paul Davis Studio**
Client **Wigwag Magazine Company, Inc.**
Principal types **Various**
Dimensions **8⅜ x 10⅞ in. (21.3 x 27.6 cm)**

Editorial Spread
Typography/Design **Bryan L. Peterson and David Lerch,**
Dallas, Texas
Letterers Bryan **L. Peterson and David Lerch**
Typographic supplier **In-house**
Studio **Peterson & Company**
Client **Southern Methodist University**
Principal types **Handlettering and Copperplate Gothic 33 B/C**
Dimensions **10⁵⁄₁₆ x 16¾ in. (27.8 x 42.5 cm)**

Poster
Typography/Design Forrest Richardson and Valerie Richardson,
Phoenix, Arizona
Writer **Forrest Richardson**
Typographic supplier **DigiType**
Studio **Richardson or Richardson**
Client **Heritage Graphics**
Principal type **Cloister**
Dimensions **24 x 36 in. (61 x 91.4 cm)**

Video
Typography/Design **Robert Valentine, Kelly Moseley,
and Nancy Laurence,** *New York, New York*
Production **Company Eye Design/Nancy Laurence and Kelly Moseley**
Typographic supplier **Boro Typographers**
Agency **Bloomingdale's Special Projects**
Client **Bloomingdale's**
Principal type **Grand R. and Ideal Schreibschrift**

PAPER ISN'T EXPENSIVE IF YOU PAY ENOUGH FOR IT!

CRANE

Booklet
Typography/Design Bill Anton, *New York, New York*
Typographic supplier Trufont Typographers
Studio Chermayeff & Geismar Associates
Client Crane & Co.
Principal types Various
Dimensions 6 x 3 in. (15.2 x 7.6 cm)

Book
Typography/Design **David Diaz,** *Carlsbad, California*
Letterer **David Diaz**
Typographic supplier **In-house**
Studio **David Diaz Illustration**
Client **David Diaz Ilustration**
Principal type **Handlettering**
Dimensions **5½ x 5½ in. (14 x 14 cm)**

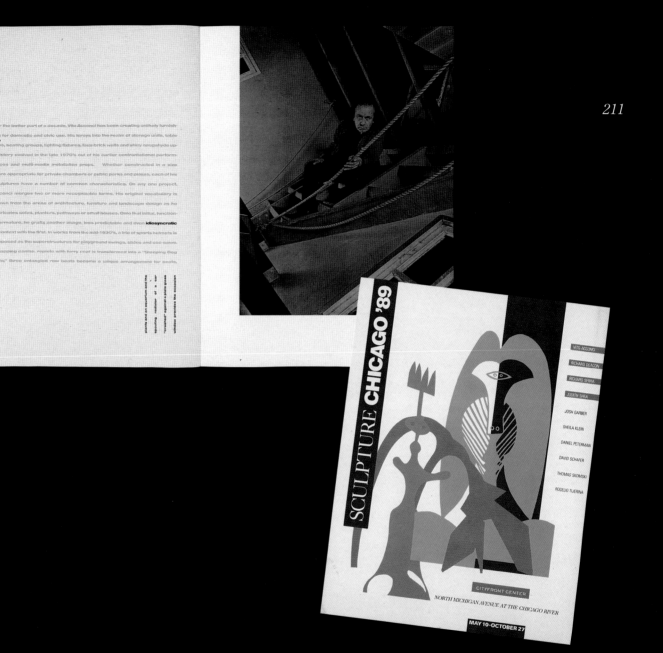

Typography/Design Kurt Meinecke, *Chicago, Illinois*
Typographic supplier Chicago Art Production Services
Studio Group Chicago
Client Sculpture Chicago '89
Principal types Helvetica Extended and Condensed
Dimensions 11 x 14⅝ in. (27.9 x 37.1 cm)

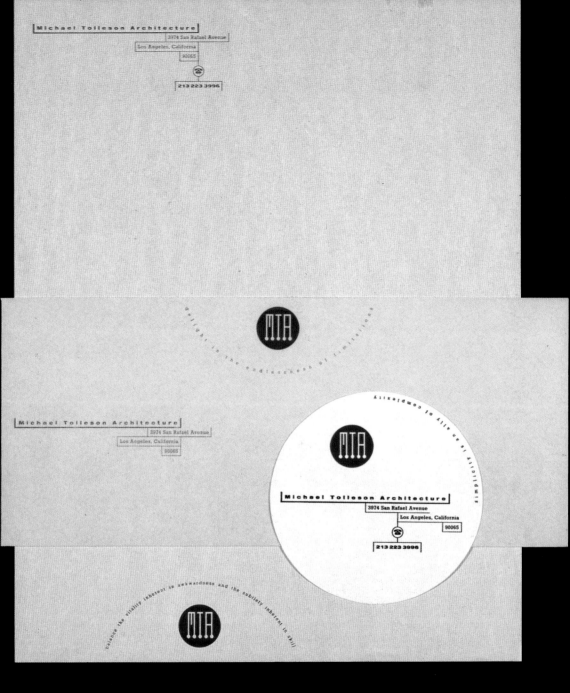

delight in the endlessness of limitations

simplicity is an act of complexity

balance the vitality inherent in awkwardness and the subtlety inherent in skill

Michael Tolleson Architecture
3974 San Rafael Avenue
Los Angeles, California
90065
213 223 3996

Typography/Design **Steven Tolleson and Bob Aufuldish,**
San Francisco, California
Typographic supplier **Spartan Typographers**
Studio **Tolleson Design**
Client **Michael Tolleson Architecture**
Principal types **Rockwell and Helvetica**
Dimensions **8½ x 11 in. (21.6 x 27.9 cm)**

Logotype
Typography/Design **Mark Fox,** *Sausalito, California*
Letterer **Mark Fox**
Typographic supplier **Andresen Typographics**
Studio **BlackDog**
Client **Embarko**
Principal type **Raleigh Gothic Condensed**

ANDRESEN TYPOGRAPHICS

5059 MELROSE AVENUE

LOS ANGELES, CA 90038

ANDRESEN TYPOGRAPHICS

1500 SANSOME ST., SUITE 100

SAN FRANCISCO, CA 94111

TELEPHONE 415-421-2900

FAX 415-421-5842

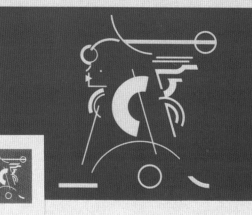

ANDRESEN TYPOGRAPHICS

2360 E. BROADWAY

TUCSON, AZ 85719

ANDRESEN TYPOGRAPHICS

2639 TWENTY-NINTH STREET

SANTA MONICA, CA 90405

TELEPHONE 213-452-5521

FAX 213-452-4997

KERRICK FOSTER
SALES REPRESENTATIVE

Stationery
Typography/Design **Keith Bright and Wilson Ong,**
Santa Monica, California
Typographic supplier **Andresen Typographics**
Studio **Bright & Associates**
Client **Andresen Typographics**
Principal type **Sabon**

Book
Typography/Design **H. Thomas Steele and Keith Bright,** *Los Angeles, California*
Publisher **Abbeville Press, Inc.**
Typographic supplier **Andresen Typographics**
Studios **H. Thomas Steele Design and Bright & Associates**
Clients **Andresen Typographics and Anderson Printing**
Principal types **Le Cochin and Publicity Gothic**
Dimensions **9¼ x 9¼ in. (23.5 x 23.5 cm)**

HOT

EVERY YEAR WE ATTEMPT TO DISCERN WHAT IS HOT. IT'S A SOMEWHAT ABSURD JOB, SINCE THE WORD "HOT" IS NEARLY IMPOSSIBLE TO DEFINE OBJECTIVELY. THIS YEAR, HOWEVER, THERE DOES SEEM TO BE ONE SPECIFIC, AND RATHER CONTRADICTORY, GENERAL TREND: AMBIVALENCE MIXED WITH COMFORT. MEANING, NO ONE WANTS TO COMMIT TO ANYTHING, BUT EVERYONE STILL LONGS TO BE IN WONDERFUL SURROUNDINGS WHILE CONSIDERING HIS OPTIONS. THESE DAYS ARE MARKED BY ADORABLE PUPPIES AND CONVENIENT ALIBIS, BY BEAUTIFUL WALLPAPER AND HANDY EXCUSES. THE GOAL OF THIS ISSUE, HOWEVER, IS TO BE UNAMBIVALENT. WHAT WE'RE ATTEMPTING IS NOT ONLY TO TAKE STOCK OF THE PRESENT AND PREDICT THE FUTURE BUT TO EXPLAIN HOW HOT HAPPENS AND WHAT ITS EFFECTS ARE. SOME OF OUR CHOICES MAY SEEM STRANGE, OTHERS OBVIOUS, BUT THE PURPOSE IS NOT SO MUCH TO ENDORSE AS TO INFORM. AFTER ALL, WE WANT YOU TO MAKE UP YOUR OWN MIND. ▸ ▸ ▸ ▸ ▸ ▸ ▸

Guest Editor **LYNN HIRSCHBERG**

ALPHABET BY DENNIS ORTIZ-LOPEZ

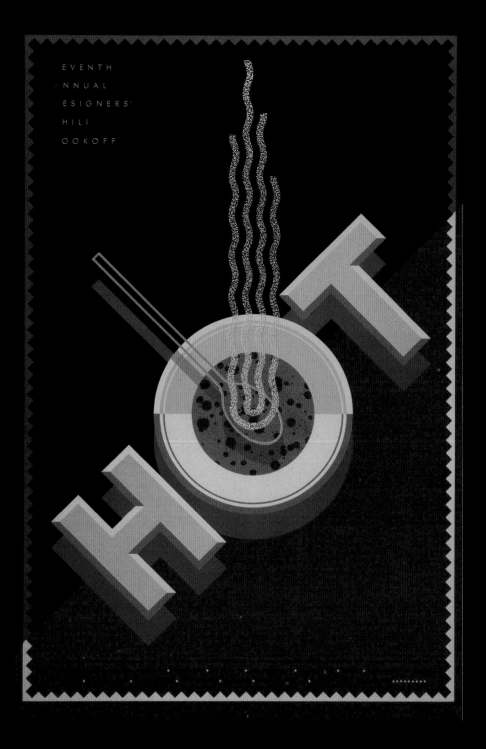

SEVENTH
ANNUAL
DESIGNERS'
CHILI
COOKOFF

HOT

Poster
Typography/Design Douglas May, *Dallas, Texas*
Letterer Douglas May
Typographic supplier Southwestern Typographics
Studio May & Co.
Client Dallas Designers' Chili Cookoff
Principal types Futura and handlettering
Dimensions 17½ x 27 in. (44.5 x 68.6 cm)

"Oh, #@*$! Who am I going to get for speaker at our next meeting? ✳;#★, it's only four weeks away and I said I'd come up with someone who could talk about creativity and really motivate our whole group. What ever possessed me to take this assignment? Now I'm really up $;✳*@'# creek!" Sound familiar? Don't worry. Just pick up the phone and dial 203-384-9443. Ask for Andy Goodman. He's President/General Manager of The American Comedy Network, a radio syndication company which currently supplies original comedy features to over 275 stations across the United States and Canada. Since 1983, Andy has served as head writer for ACN, honing the unique skills of communicating and being funny with sound. For the last 2 years, Andy has been crisscrossing the country talking to groups like yours about two important subjects: "The Power of Sound" and "Writing Funny." "The Power of Sound" is a 45-minute presentation that dramatically demonstrates radio's unique ability to reach people's hearts and minds like no other medium can. Broadcasters and advertisers alike have found the talk inspirational in making them rethink the ways they use the medium of radio. "Writing Funny" (also known as "A Workshop for Sit-down Comics") is a 1-hour seminar that teaches people how to unlock their own creativity and "write funny" on deadline – for radio, TV, or print. Most importantly, it gives you definitive, useable techniques you can begin applying to your work immediately. So, if you're planning a "Radio Day," a monthly Ad Club luncheon, evening program, a meeting of a single radio station or a large group of stations, don't panic. Give Andy a call and ask for more information about "The Power of Sound" or "Writing Funny." He may be just the speaker you've been looking for. No shit!

Poster
Typography/Design **Marissa von Gretener,**
Old Greenwich, Connecticut
Typographic supplier **Low Key Typographers, Inc.**
Studio **Frank C. Lionetti Design Inc.**
Client **American Comedy Network**
Principal type **Gill Sans**
Dimensions **24 x 28½ in. (61 x 72.4 cm)**

TDC

Type Directors Club

Officers 1989/90

Officers 1990/91

Committee for TDC 36

Type Directors Club Presidents

Frank Powers, 1946, 1947
Milton Zudeck, 1948
Alfred Dickman, 1949
Joseph Weiler, 1950
James Secrest, 1951, 1952, 1953
Gustave Saelens, 1954, 1955
Arthur Lee, 1956, 1957
Martin Connell, 1958
James Secrest, 1959, 1960
Frank Powers, 1961, 1962
Milton Zudeck, 1963, 1964
Gene Ettenberg, 1965, 1966
Edward Gottschall, 1967, 1968
Saadyah Maximon, 1969
Louis Lepis, 1970, 1971
Gerard O'Neill, 1972, 1973
Zoltan Kiss, 1974, 1975
Roy Zucca, 1976, 1977
William Streever, 1978, 1979
Bonnie Hazelton, 1980, 1981
Jack George Tauss, 1982, 1983
Klaus F. Schmidt, 1984, 1985
John Luke, 1986, 1987
Jack Odette, 1988, 1989
Ed Benguiat, 1990

TDC Medal Recipients

Hermann Zapf, 1967
R. Hunter Middleton, 1968
Frank Powers, 1971
Dr. Robert Leslie, 1972
Edward Rondthaler, 1975
Arnold Bank, 1979
Georg Trump, 1982
Paul Standard, 1983
Herb Lubalin, 1984 (posthumously)
Paul Rand, 1984
Aaron Burns, 1985
Bradbury Thompson, 1986
Adrian Frutiger, 1987
Freeman Craw, 1988
Ed Benguiat, 1989

Special Citations to TDC members

Edward Gottschall, 1955
Freeman Craw, 1968
James Secrest, 1974
Jerry Singleton, 1982
Olaf Leu, 1984
William Streever, 1984

International Liaison Chairpersons

Ernst Dernehl
Dernehl & Dernehl
Design Consultants
Box 150 60
S–400 41 Goteborg
SWEDEN

Japan Typography Association
C C Center
4–8–15 Yushima,
Bunkyo–ku
Tokyo 113
JAPAN

Christopher Dubber
FACE Photosetting
4 rue de Jarente
75004 Paris
FRANCE

Bertram Schmidt Friderichs
Universitatsdruckerei und Verlag
H. Schmidt GmbH & Co.
Robert Koch Strasse 8
Postfach 42 07 28
D–6500 Mainz 42
WEST GERMANY

David Quay
Studio 12
10–11 Archer Street
SoHo
London W1V 7HG
ENGLAND

David Minnett
President
Australian Type Directors Club
P.O. Box 1887
North Sydney 2060
AUSTRALIA

Type Directors Club
60 East 42 Street
Suite 1416
New York, NY 10165–0015
212–983–6042 FAX 212–983–6043

Carol Wahler, Executive Director

*For membership information please contact
the Type Directors Club office.*

221

Mary Margaret Ahern '83
Colella Angelo '90
Leonard F. Bahr '62
Peter Bain '86
Don Baird '69
Colin Banks '88
Clarence Baylis '74
Felix Beltran '88
Edward Benguiat '64
Anna Berkenbusch '89
Peter Bertolami '69
Emil Biemann '75
Godfrey Biscardi '70
Roger Black '80
Anthony Block '88
Sharon Blume '86
Art Boden '77
Karl Heinz Boelling '86
Friedrich Georg Boes '67
Garrett Boge '83
David H. Bone '89
Ron Brancato '88
David Brier '81
Ed Brodsky '80
Kathie Brown '84
William Brown '84
Werner Brudi '66
Bill Bundzak '64
Aaron Burns '54
John Burton '85
Jason Calfo '88
Ronn Campisi '88
Daniel Canter '82
Tom Carnase '73
Matthew Carter '88
Ken Cato '88
Younghee Choi '86
Lawrence Chrapliwy '87
Alan Christie '77
Ronnie Tan Soo Chye '88
Robert Cipriani '85
Ed Cleary '89
Travis Cliett '53
Mahlon A. Cline* '48
Elaine Coburn '85
Tom Cocozza '76
Barbara Cohen '85
Ed Colker '83
Freeman Craw* '47
James Cross '61
David Cundy '85
Rick Cusick '89

Derek Dalton '82
Susan Darbyshire '87
Ismar David '58
Whedon Davis '67
Cosimo De Maglie '74
Robert Defrin '69
Ernst Dernehl '87
Claude Dieterich '84
Ralph Di Meglio '74
Lou Dorfsman '54
John Dreyfus** '68
Christopher Dubber '85
Curtis Dwyer '78
Rick Eiber '85
Bruce Elton '88
Eugene Ettenberg* '47
Leon Ettinger '84
Florence Everett '89
Bob Farber '58
Sidney Feinberg* '49
Amanda Finn '87
Lawrence Finn '87
Yvonne Fitzner '87
Holley Flagg '81
Norbert Florendo '84
Tony Forster '88
Dean Franklin '80
Carol Freed '87
Elizabeth Frenchman '83
F. Eugene Freyer '88
Adrian Frutiger** '67
Patrick Fultz '87
Andras Furesz '89
Christof Gassner '90
David Gatti '81
Stuart Germain '74
John Gibson '84
Lou Glassheim* '47
Howard Glener '77
Jeff Gold '84
Alan Gorelick '85
Edward Gottschall '52
Robert Goulden '88
Norman Graber '69
Diana Graham '85
Austin Grandjean '59
Adam Greiss '89
Kurt Haiman '82
Allan Haley '78
Edward A. Hamilton '83
Mark L. Handler '83
William Paul Harkins '83

Sherri Harnick '83
Horace Hart '67
Knut Hartmann '85
Bonnie Hazelton '75
Elise Hilpert '89
Diane Hirsch '89
Michael Hodgson '89
Fritz Hofrichter '80
Kevin Horvath '87
Gerard Huerta '85
Donald Jackson** '78
John P. Jamilkowski '89
Jon Jicha '87
Allen Johnston '74
R. W. Jones '64
Choi Kai-Yan '90
R. Randolph Karch* '47
Louis Kelley '84
Michael O. Kelly '80
Scott Kelly '84
Tom Kerrigan '77
Renee Khatami '90
Zoltan Kiss '59
Robert Knecht '69
Tom Knights '85
Steve Kopec '74
Bernhard J. Kress '63
Walter M. Kryshak '84
Mara Kurtz '89
Raymond Laccetti '87
James Laird '69
Guenter Gerhard Lange '83
Jean Larcher '81
Judith Kazdym Leeds '83
Louis Lepis '84
Professor Olaf Leu '66
Jeffery Level '88
Mark Lichtenstein '84
Clifton Line '51
Wally Littman '60
Sergio Liuzzi '90
John Howland Lord* '47
John Luke '78
Ed Malecki '59
Sol Malkoff '63
Frank Marchese '88
Marilyn Marcus '79
Stanley Markocki '71
John S. Marmaras '78
Adolfo Martinez '86
James Mason '80
Les Mason '85

Jack Matera '73
Frank Mayo '77
Fernando Medina '78
Egon Merker '87
Professor Frederic Metz '85
Douglas Michalek '77
John Milligan '78
Michael Miranda '84
Oswaldo Miranda '78
Barbara Montgomery '78
Richard Moore '82
Ronald Morganstein '77
Minoru Morita '75
Raymond Morrone '88
Tobias Moss* '47
Richard Mullen '82
Keith Murgatroyd '78
Erik Murphy '85
Jerry King Musser '88
Louis A. Musto '65
Rodney Mylius '89
Alexander Nesbitt '50
Paschoal Fabra Neto '85
Robert Norton '88
Alexa Nosal '87
Josanne Nowak '86
Jack Odette '77
Thomas D. Ohmer '77
Motoaki Okuizumi '78
Brian O'Neill '68
Gerard J. O'Neill* '47
Bob Paganucci '85
Luther Parson '82
Charles Pasewark '81
Eugene Pattberg* '47
Alan Peckolick '86
B. Martin Pedersen '85
Robert Peters '86
Roy Podorson '77
Will H. Powers '89
Vittorio Prina '88
Richard Puder '85
David Quay '80
Elissa Querzè '83
Robert Raines '90
Erwin Raith '67
Adeir Rampasso '85
Paul Rand** '86
Hermann Rapp '87
Jo Anne Redwood '88
Bud Renshaw '83
Jack Robinson '64

Edward Rondthaler* '47
Robert M. Rose '77
Herbert M. Rosenthal '62
Tom Roth '85
Dirk Rowntree '86
Joseph E. Rubino '83
Erkki Ruuhinen '86
Gus Saelens '50
Howard Salberg '87
Bob Salpeter '68
David Saltman '66
John N. Schaedler '63
Jay Schechter '87
Paula Scher '88
Kathy Schinhofen '89
Hermann J. Schlieper '87
Hermann Schmidt '83
Klaus Schmidt '59
Bertram Schmidt-Friderichs '89
Werner Schneider '87
Eileen Hedy Schultz '85
Eckehart Schumacher-Gebler '85
Robert Scott '84
Michael G. Scotto '82
Gene Paul Seidman '87
William L. Sekuler* '47
Paul Shaw '87
George Sohn '86
Martin Solomon '61
Jan Solpera '85
Mark Solsburg '89
Jeffrey Spear '83
Lisa Speroni '88
Erik Spiekermann '88
Vic Spindler '73
Paul Standard** '86
Rolf Staudt '84
Walter Stanton '58
Mark Steele '87
Murray Steiner '82
Carole Steinman '88
Sumner Stone '88
William Streever '50
Ilene Strizver '88
Hansjorg Stulle '87
Ken Sweeny '78
Gordon Tan '90
William Taubin '56
Jack George Tauss '75
Pat Taylor '85
Anthony J. Teano '62
Bradbury Thompson '58

David Tregigda '85
Susan B. Trowbridge '82
Paul Trummel '89
Lucile Tuttle-Smith '78
Edward Vadala '72
Roger van den Bergh '86
Jan Van Der Ploeg '52
James Wageman '88
Jurek Wajdowicz '80
Robert Wakeman '85
Julian Waters '86
Jessica Weber '88
Professor Kurt Weidemann '66
Ken White '82
Gail Wiggin '90
James Williams '88
Conny Winter '85
Bryan Wong '90
Antonio Munoz Yuste '90
Hal Zamboni* '47
Professor Hermann Zapf** '52
Roy Zucca '69

223

Sustaining Members
Arrow Typographers '75
Boro Typographers '89
Characters Typographic
 Services, Inc. '85
CT Photogenic Graphics '86
Graphic Technology '88
The Graphic Word '87
International Typeface
 Corporation '80
Linotype Company '63
Pastore DePamphilis Rampone
 '76
Photo-Lettering, Inc. '75
ROR Typographics Inc. '89
Royal Composing Room '55
219Type, Inc.
Type Consortium Limited '87
The Type Shop '88
Typesetting Service Corporation
 '88
TDC Laser Imaging '88
Typographic House '60
Typographic Images '86
TypoGraphic Innovations Inc. '72
TypoVision Plus '80

TYPOGRAPHIC SUPPLIERS